Doug,

To my fourth day

Brother

– Remember God does

not stop evil

– He consoles us

– <u>He</u> forgives

– <u>He</u> JUDGES NOT US!

Brian

Finding

GOD

in the

SHACK

Seeking truth in a story *of evil and redemption*

ROGER E. OLSON

IVP Books

An imprint of InterVarsity Press
Downers Grove, Illinois

InterVarsity Press
P.O. Box 1400, Downers Grove, IL 60515-1426
World Wide Web: www.ivpress.com
E-mail: email@ivpress.com

InterVarsity Press® is the book-publishing division of InterVarsity Christian Fellowship/USA®, a movement of students and faculty active on campus at hundreds of universities, colleges and schools of nursing in the United States of America, and a member movement of the International Fellowship of Evangelical Students. For information about local and regional activities, write Public Relations Dept., InterVarsity Christian Fellowship/USA, 6400 Schroeder Rd., P.O. Box 7895, Madison, WI 53707-7895, or visit the IVCF website at <www.intervarsity.org>.

Design: Cindy Kiple

Images: comet in the sky: Digital Vision/Getty Images
 shack: Pete Ryan/Getty Images

ISBN 978-0-8308-3708-3

Printed in the United States of America ∞

Library of Congress Cataloging-in-Publication Data

Olson, Roger E.
 Finding God in The shack: seeking truth in a story of evil and
 redemption/Roger E. Olson.
 p. cm.
 ISBN 978-0-8308-3708-3 (pbk.: alk. paper)
 1. Young, William P. Shack. 2. Christianity in literature. I.
 Title.
 PR9199.4.Y696S5336 2009
 813'.6—dc22
 2008054472

P	20	19	18	17	16	15	14	13	12	11	10	9	8				
Y	25	24	23	22	21	20	19	18	17	16	15	14	13	12	11	10	09

To my wife, Becky.

Contents

1

Why a Book About
The Shack?

EVERYONE WHO HAS EVER FELT A GREAT SADNESS, or who knows someone who has, can relate to *The Shack*. This novel is about the Great Sadness—the terrible burden of grief that often accompanies and follows a devastating loss. It may be the death of a loved one. It may be financial ruin. It may be divorce or abandonment. Whatever its cause, the Great Sadness is part of the human condition.

People often ask "Where is God?" when pressed down by the Great Sadness. Where was God when my husband or wife died? Where was God when my brother was killed in a car accident, leaving behind a young family? Where was God when a storm destroyed my town, including my home? Where was God when terrorists attacked and killed so many people?

Probably no question about God disturbs Christians and non-Christians more than this one: How can an all-good, all-powerful God cause or even allow such horrible loss of human life? How can a

God of love allow the departure of someone I love so dearly? Especially if that departure involves pain and suffering, and leaves wreck and ruin in its wake. These questions cause people to wonder about God's character. This is probably why *The Shack* by William P. Young has sold millions of copies, and almost every copy is being read by two or three people. It speaks to these questions—especially the question of God's character—in a powerful way.

The Shack reminds me of the popular television series *Touched by an Angel*. Both delve into some pretty deep waters about God, suffering, evil and free will without mentioning any theologian, Christian church or doctrinal tradition. And in that way *The Shack* too appeals to our postdenominational culture.

While *The Shack* is overtly Christian, those who don't share the Christian faith can and do find it enjoyable. But it seems to be aimed primarily at a Christian audience. And its purpose, beyond spinning an amazingly good yarn, seems to be to correct certain popular notions about God and point readers toward other ideas about God. There can be no doubt that William Young is theologically trained, but he hides most of that well. The reader isn't assaulted by heavy theological jargon but is sweetly seduced into some profound theological thinking.

Before we begin looking at *The Shack* in detail, I'll give a synopsis of the plot. Any who haven't read the book should consider putting this book down and reading *The Shack* first. (It will probably only take a few hours. My wife couldn't put it down until she finished it.)

Spoiler alert! I'm going to give away the ending very soon.

A SYNOPSIS

The hero of the story is God, to be specific, Jesus. But the protagonist

is Mack. And like many people Mack lives with the burden of the Great Sadness. The story begins with an account of Mack's personal history. He was raised in an abusive home, where his father, a very religious man, beat him severely many times. Later he attended seminary for a while but didn't especially relate to what he was taught there. One thing he was taught is that God doesn't speak anymore; he stopped directly communicating with people after the Bible was written. Mack married his sweetheart Nan. They live in Oregon and have five "unusually beautiful kids." The youngest one is Missy, a sweet child especially precious to Mack.

Mack takes his three youngest children on a camping trip in the Oregon wilderness. While Mack and everybody else are struggling with a capsized canoe in the nearby lake, Missy disappears. After frantically searching for Missy, Mack and other campers finally realize, based on some irrefutable evidence, that she has been kidnapped. The authorities never find her body but discover her bloody dress in an old shack near the lake.

The Great Sadness descends on Mack and engulfs him. Apparently he falls into a deep depression during which he is tempted to accuse God and himself for Missy's fate. But one day he finds a note in the family mailbox. It says, "Mackenzie [Mack's first name], It's been a while. I've missed you. I'll be at the shack next weekend if you want to get together." The note is signed "Papa," which is Nan's favorite name for God.

Mack sneaks off to the shack where Missy's bloody dress was found to see if Papa (God) will show up. He's dubious about that possibility and suspects he's the victim of a hoax, but his desperation drives him to try anything. While he's at the shack, God does show up—in the form of a jolly, rather large black woman, whom he dis-

covers is Papa. Then Mack encounters a friendly carpenter, Jesus, and a wispy young female figure called Sarayu, who is obviously the Holy Spirit. These three engage Mack in conversation about his life, Missy's murder and God's role in human events.

The four characters chop wood, explore the beauty of God's creation, cry together, talk about life and death, lie on the dock at night looking up at the starry sky and go for long hikes that lead to some pretty startling places. The bulk of the book narrates Mack's time with God at the shack. It would be easy to suppose this was all a dream. But the book's ending reveals it was not meant to be a dream. We are supposed to believe that God really appeared to Mack as a trinity of three distinct people bound together in a community of perfect love. Papa, Jesus and Sarayu take Mack on a journey to understand why terrible things happen to human beings and what God has to do with it. The point of it all is that God is worthy of trust, and we shouldn't judge God.

After some agonizing but enlightening conversations with God, Mack is allowed to see Missy through a waterfall. The veil between earth and paradise, as it were, is made thin by God so they can see each other, but they can't touch or talk to one another. Mack observes that Missy is happy where she is, and God assures him that even in her darkest hour her thoughts and prayers were mainly for him, his wife and Missy's siblings.

Mack also gets a wider vision of heaven as thousands of souls appear in a meadow at night. They look to Mack like multicolored lights. And he sees angels and other heavenly beings, including a majestic Jesus. During this event (whether vision or reality) Mack encounters his abusive father and they embrace tearfully. Mack forgives his father just as the heavenly Father has forgiven him. God tells

Mack that everyone is already forgiven because of what Jesus did on the cross, but that people have to accept forgiveness for it to benefit them. Apparently, at some point Mack's father accepted God's forgiveness, because he is among the heavenly host.

Finally, God leads Mack on a long hike to find Missy's body. They extract it from a cave where the murderer had put it and take the body back to the shack, where Jesus has finished a beautiful casket. They lay the body carefully in the casket and bury it. By now Mack has come to terms with his daughter's death and is no longer angry at God or himself. The Great Sadness has lifted from his shoulders.

Mack returns from his encounter with God and tells his wife. Nan is surprised but believes him. Together and with a friendly policeman they know, they go to the cave and retrieve Missy's body for proper burial. This raises questions about how real the encounter between God and Mack was supposed to be. If God and Mack had already retrieved Missy's body, why was it back in the cave? That makes Mack's experience sound more like a vision or dream. But apparently we're not supposed to think it was either of these.

THE SHACK RINGS TRUE

I believe *The Shack* is more than a religious novel; it is a true story. It's not true in the sense that I believe the events described actually happened but in that the story basically fits human experience and what the Bible says. Like Jesus' parables, such as the Prodigal Son and the Good Samaritan, *The Shack* is teaching us something. It's supposed to teach that life is tough but we can trust God anyway. It teaches us something about God's character and his relationship with the world of pain and misery. Maybe it's supposed to teach that life is arbitrary, but God is not. Very bad things happen to everyone,

but God is not out to get us, and even in the midst of the very worst pain imaginable he is there with those who suffer.

Why do I think *The Shack* has something important to teach? The book rings true to my own experience. I've experienced a Great Sadness in my life, and I've judged God by demanding to know where he was. God has been good to me anyway and gently led me out of that dark night of the soul—several times! Once he did this by speaking directly to me: I had a conversation with God.

I too was abused by my father. He was a pastor, and everyone thought he was a wonderful man of God. But I knew better. He was an evil man, at least in his later years. He didn't hit me, but he might as well have. He said terrible, demeaning, humiliating things to me, which amounted to rejection. He even asked me to get out of his life and leave him alone when I attempted to intervene to keep him from going to prison. He ended up in prison in spite of all my warnings. And *he blamed me* even though I had nothing to do with his problems. My father's problems and abuse took place off and on over a period of almost twenty-five years, and it led to the total dissolution of my family of birth. I was so torn up that I almost lost faith in God. I began to doubt God's goodness or his involvement in my life. Why was he letting these things happen to me and my family? I struggled especially because my father and I ministered together; for some years I was his assistant pastor. I trusted him implicitly. In some way he represented God to me. And he turned out to be a complete hypocrite and worse.

I'm not comparing my experience with Mack's. I can only imagine what Mack's Great Sadness was like. I suspect only someone who has had a child kidnapped and murdered can know. I have an inkling, though, because when our daughter was four years old we

thought she had been kidnapped, and those ten minutes were the most horrible in my life. I was beside myself. And I knew intuitively and immediately that if she had been kidnapped I'd never forgive myself or enjoy life again.

As it turned out she had wandered out of our apartment-complex courtyard and into the parking lot, where she hid behind a dumpster. She watched as I frantically ran around calling her name. For some reason she was afraid to come out. Back in the courtyard I pounded on doors and begged for help locating her. Finally, feeling hopeless because I was absolutely sure she was gone, I picked up the phone to call the police. Right then a man looking like a gangster biker, the kind of person we would cross the street to not encounter, walked into the courtyard carrying my daughter and asking loudly, "Is this someone's little girl?" I don't remember anything after that. I don't know if I thanked him or not. I kind of blanked out, took her out of his arms and carried her to our apartment.

I thank God for rescuing our daughter and causing her to be found by a kind person. Though that event didn't crush me, I can imagine what Mack experienced.

My father's words and actions, however, did crush me. It broke my spirit. I went through the motions of living. Night after night I had horrible dreams of fear and anger and confusion. Then, one day while I was jogging and praying (yes, I prayed even as I doubted and questioned), God intervened. Out of the blue, without any preparation or warning, God spoke into my life. I knew intuitively it was him. I didn't hear any audible voice, but I didn't have to. I won't go into the details; suffice it to say that the event and its aftermath convinced me that God was still very real and in my life.

So, as I read Mack's story I didn't find it hard to believe. I know

God speaks to people today. And I know what the Great Sadness feels like. And most of the things God said to Mack resonate very much with what I have come to believe based on my reading of Scripture and my experience of God's mercy.

LEARNING TO TRUST GOD

This is what I believe about *The Shack:* the author, William P. Young, or someone close to him experienced a terrible, indescribably evil event. He was seminary trained but that didn't prepare him for what happened. His trust in God was shattered, but he tried desperately to hold on to God, not realizing that God was holding on to him. He tried to hide the Great Sadness, but his wife and a few others could see it. They didn't know what to do for him.

Then God intervened. I don't know exactly how, of course, but something happened to this man that brought him to a new awareness of God's character and God's ways. This renewed his trust in God and assured him that no matter how awful the event behind the Great Sadness was, something good could come of it.

I still don't know what good could possibly come from what happened to my family. Neither does Mack. Both of us simply met God in a new way and found out that God knows what he is doing, so we can trust him. I don't mean that God plans evil or suffering and inflicts them on us. That's not the book's message, nor is it the moral of my life story. Rather, God knows why he allows terrible things to happen, and he is not absent from us when they happen. But God can bring good out of them even though the evil events themselves are not good.

I believe there are such amazing truths in *The Shack* that God might use it to take away our Great Sadness. That's its purpose. The

author surely wrote it with the hope that through it God would heal wounds of distrust and bring some readers back to himself.

THE SHACK AND THE BIBLE

The Shack communicates great truths about God that are both biblical and resonate with experience. But I disagree with some elements of the story. Here and there I quibble with some details that don't seem to fit the book's character. Other elements, though, beg correction. I question some things Young puts in God's mouth, believing that they might lead to heresy if taken to an extreme. I don't think these completely undermine the book, but they need a question mark placed over them. If we bracket them and set them aside, we can benefit from the story as a whole.

The approach I take in this book is to focus on some of *The Shack*'s main themes. The question found in the title of each chapter usually offers a springboard into several key topics. And as a theologian, I can't help but use the ideas and events in *The Shack* to zero in on some sound doctrine. I want to explore why some of the controversial ideas in the book are quite correct and why some are not.

By what criteria do I decide whether something God says to Mack in *The Shack* is theologically correct or not? I don't turn to the Bible and pull out individual Bible verses (proof texts) to prove a point. That rarely works, because another person can usually find contradicting proof texts. We can't always discern the clear and unequivocal mind of God by compiling lists of proof texts. I believe the Bible speaks as a whole even when there are seemingly contrary notes. It's like a choir concert. There may be a couple of voices out of tune but the melody is nevertheless clear.

Who is the God of the Bible? I think Jesus is our best clue to God's

identity and character, even though Jesus is not *all* of God. I will often appeal to a panoramic vision of the Bible as my criterion for discernment when examining a particular saying in *The Shack*. I'll argue that in some cases what God says in *The Shack* does not fit with the Bible's vision. At the same time, while *The Shack* never quotes the Bible, it clearly relies on a holistic vision of the God of the Bible and expresses that in God's words to Mack.

2

Where Is God in Senseless, Innocent Suffering?

WE'VE ALL HEARD SOMEONE SAY "God is in control" or "It was God's will" when a terrible calamity befalls another person. When it's the painless death of a person who is Christian, such statements *might* make some sense. But what if it's the horrible, agonizing, slow death of a child who had leukemia? Or how about death by rape and violence? Then those glib answers aren't helpful, and *The Shack* denies their truth and offers a picture of God's involvement that is both plausible, reassuring and biblical.

THE PROBLEM OF EVIL

Through the ages people have pondered the character of God and the problem of evil: If God is perfectly good and perfectly powerful, he would want to and could stop evil. But evil continues. Therefore God is either not perfectly good or not perfectly powerful, or he does not exist. Someone has called this "the rock of atheism" because dur-

ing the twentieth century God's very existence has been widely doubted due to the sheer weight of horrendous evils.

The Shack addresses the problem of evil head-on. It's one thing to wonder about evil in the abstract, but it's entirely different to personally face calamity and reconcile it with God's goodness and power. Mack allows his outrage at the murder of Missy to sink deep into his bones. I don't blame him. But I've heard preachers say that whenever something bad happens to us we should thank God because it is part of his great plan to bring about a greater good for his own glory. That sends shivers down my spine. I wonder if those preachers have felt the horror of a loss like Mack's.

I have to admit, though, I met a man who experienced horrendous loss and saw it as something good. He is an evangelical Christian who spoke in the college chapel where I taught. God, he proclaimed, killed his son in a mountain-climbing accident, and only belief that God took his son's life gave him hope and kept him from despair. God would only take a life for a reason. Thus his son's death was not random, but planned and perfectly executed.

But what if his son's death had been slow and agonizing? What if his child was kidnapped and murdered by a sadistic killer? Would God plan and cause such horrible things? *The Shack* uses such a worst-case scenario because it happens. And when it does, where is God?

Some years after hearing the "God killed my son" sermon, I heard a Christian philosopher talk about his son's death. (The philosopher is ordained in a denomination that teaches God's meticulous providence—that whatever happens is planned and caused by God for a greater good.) As he stood by his little boy's grave, he thought, *I will never tell another parent whose child has died, "It was God's will."* I'm guessing, although I don't know for sure, that his little boy suffered as he died.

DISAPPOINTMENT WITH GOD

Mack's Great Sadness is understandable. And so is his disappointment with God. Mack asks, "God, how could this happen?" (p. 53). Later he accuses God by saying, "If you couldn't take care of Missy, how can I trust you to take care of me?" (p. 92). Then he utters the most powerful accusation of all: "God is to blame" (p. 161). We may recoil with horror. How dare a mere mortal accuse God of anything! But the Psalms are full of this kind of accusation. The psalmist lashes out at God in Psalm 77. Yes, he always comes around to expressing trust in God's goodness, but clearly there were times when he fell into despair.

In the middle of an awful crisis and the ensuing dark night of the soul, Mack's response is normal, especially since he's been taught that God is in control. *The Shack* portrays Mack as Everyman. He's neither saint nor special sinner. He's us. His anguished cry and accusation against God is simply human.

The author of *The Shack* believes we will empathize with Mack and wants us to know it's okay to be frustrated and even angry with God so long as it doesn't become our permanent condition. The whole point of the book is to give us hope about the goodness of God that lifts us out of such despair. But first comes the Great Sadness, including anger at God. And it's okay even if it isn't a good place to stay.

I'm sure some readers believe it is always wrong to question or be angry with God. But what about Job? True, Job refuses to curse God as his wife suggests, even though he is covered with boils and all his sons and daughters are killed. Is the moral of the story that we must never question God? No. It's one thing to curse God and quite another to question or even be angry with him. God doesn't punish Job for being angry; he answers him and his friends out of a whirlwind.

God simply says, "You don't know me or my ways."

The Shack says that too. God tells Mack several times that he cannot possibly understand God's ways. God also offers something of an account of himself to Mack, and he points the finger back at Mack and all of humanity. (We'll explore this in more detail in chapter five.) But Mack's feelings, though unjustified, are understandable, and God won't punish us for those feelings either. *The Shack*'s message is that we don't have to remain stuck in those feelings of anger with God.

GOD SUFFERS WITH US

Where is God when we or our loved ones suffer? According to *The Shack*, God is suffering along with us. The God of *The Shack* differs considerably from the God of popular folk religion and classical theism. Classical theism is the highly philosophical description of God found in many books on theology and doctrine. That God is often described as incapable of change (immutable) and incapable of suffering (impassible). Of course, God is immutable in the sense that no one or nothing else can force him to change. And God is impassible in the sense that nothing can cause God to suffer. But this is not what the theology books mean by these terms.

The God of much theology is passionless, whereas the God of the Bible is passionate; the God of much theology cannot suffer, whereas the God of the Bible suffers with his people. Do we really believe that God didn't suffer when his Son died on the cross? What father could watch his son die that kind of cruel execution and not suffer?

William Young seems to have learned from some contemporary Christian thinkers who suggest that the God of philosophy is not the God of Abraham, Isaac and Jacob—or Jesus. The author wants us to

think of God along the lines of a perfect parent. God certainly is more powerful than any parent, but he does not feel any less than a good parent feels. It might make philosophical sense to say God cannot suffer, but it doesn't make biblical sense.

Where was God when Missy was kidnapped and murdered? In *The Shack* God says, "There was not a moment that we [Father, Son and Holy Spirit] were not with her" (p. 173). God doesn't explain how he was with her, but that doesn't matter. Mack finds it helpful to know that Missy did not suffer and die alone. The most loving and powerful presence in the world was with her and surely bore her suffering alongside her.

God tells Mack: "Papa [God] has crawled inside your world to be with you" (p. 165). The God of *The Shack* is not some distant, controlling deity who inflicts pain on us for some greater good without feeling it himself; God is right here with us like any good parent would be. (Some will object to Papa's apparent incarnation, which we'll examine in chapter three.)

When I was ten years old I spent much of one summer in the hospital. I was told that I might die if I did not lie perfectly still. I felt like a pin cushion with all the needles stuck into me. And my joints hurt like crazy! I had a very bad case of rheumatic fever. But even my very imperfect stepmother, who hadn't filled the doctor's prescription for penicillin for my strep throat a week before I came down with rheumatic fever, came to the hospital and sat with me for hours and hours. She read to me and talked with me and was a comforting presence just sitting there. I believed she was bearing some of my suffering for me. I was emotionally and maybe even physically better because of her self-sacrificing bedside presence. Surely God is a better parent than my stepmother!

In the book *Night* Elie Wiesel recounts an execution in a Nazi concentration camp during World War II. The prisoners were made to watch as a young boy was hanged. He was so light that the weight of his body did not break his neck, so he died slowly of asphyxiation. While the boy suffered strangulation, a prisoner cried out, "Where is God?" A voice from the crowd responded, "Right there on the gallows." If God cannot suffer, there is no adequate answer. Why wouldn't God be on the gallows or with Missy as she was murdered? Where else would God be if he is a perfect parent?

EVIL AND FREE WILL

This isn't the whole story. If it were it would offer little hope. A philosopher defined God as "the fellow sufferer who understands." That's not much better than the God who cannot feel our pain. But those aren't the only options. In *The Shack* God explains to Mack that there was nothing he could do to stop Missy's suffering and death.

Before attempting to understand why God said this, we need to take a look at the human condition. This world, according to *The Shack*, is shattered and broken. This is not a nice place. It's a world where evildoers like "the Little Ladykiller," who kidnapped Missy, stalk, rape and murder children. It's a world of sin and evil. But did God *plan* it this way? Does God *cause* it to be this way? Most emphatically no. Evil, the God of *The Shack* tells Mack, is here because of "the will to power and independence" in human beings. (The author doesn't mention angelic beings.)

God's response to Mack's accusation that God did nothing to stop Missy's fate is thoroughly biblical and true to experience. In Romans 1 Paul tells us that we humans want to go our own way. So God lets us,

which leads to death and destruction. *The Shack* makes it clear that we want independence from God, which amounts to making ourselves our own gods. Evil is not the result of God's plan or action, but of our rebellion. (For more on free will, sin and evil, see chapter four.)

Jesus tells Mack how the human declaration of independence from God has affected the whole world:

> Our earth is like a child who has grown up without parents, having no one to guide and direct her. . . . Some have attempted to help her but most have simply tried to use her. Humans, who have been given the task to lovingly steer the world, instead plunder her with no consideration, other than their immediate needs. . . . So they use her and abuse her with little consideration and then when she shudders or blows her breath, they are offended and raise their fist at God. (p. 144)

In other words, our rebellion against God has brought a curse on creation. Evil and inhumanity and innocent suffering are parts of that curse.

Why doesn't God fix the world? Why doesn't he lift the curse? *The Shack*'s answer boils down to this: God gave the earth to us; that's why he doesn't unilaterally fix it. For the time being God does not violate our free will because love does not force its will on others (p. 145).

The answer to the problem of evil found in *The Shack* is clearly free will. God loves humans so much he gave us the option of loving him or not. We chose freely to declare our independence from God. We see the results in the daily newspaper. All of it is our doing; not God's. But God is not absent. He mercifully stays with us and works to bring good out of the evil we do, hoping we'll realize our need for

him and begin to trust him instead of ourselves.

In one of the most powerful statements in *The Shack,* Sophia, a personification of Papa's wisdom, tells Mack that God doesn't stop many things that cause pain and suffering, even though they cause him pain and suffering too. We insisted on having our independence, and now we are angry with God for loving us enough to give us what we demanded. Sophia explains to Mack that right now nothing is as it should be, the world is severely broken, but it will be set right some day. In this fallen world, lost in chaos and darkness, terrible things happen to people God is especially fond of. Mack strenuously objects, "Then why doesn't he do something about it?" Sophia replies, "He chose the way of the cross where mercy triumphs over justice because of love" (p. 164).

In other words, God has the power to stop all evil and suffering, but that would require taking back the gift of free will. For now, at least, God is honoring our demand for independence, and is using his power of suffering love and mercy to bring us back to himself. If he unilaterally stopped all evil, people would not be free.

Evil is a mystery that we can never fully understand. Free will is not the final word about God's involvement in this world. Actually, God sometimes steps in to prevent or interrupt evil acts, but more often he doesn't. God tells Mack the reason is embedded in the particularities of each situation, which we couldn't possibly understand (p. 125). *The Shack* implies that God voluntarily abides by certain rules that govern how much and how often he can interfere without destroying our free will.

The final answer to suffering is hope. Throughout the book God repeatedly points to the future. For example, he says to Mack, "If you could only see how all this ends and what we will achieve without the

violation of one human will—then you would understand. One day you will" (p. 125). God tells Mack that there is no justification for evil, only redemption.

The Shack's proposal for understanding God's involvement in evil is the only one that really gives hope and makes sense of the Jesus story. Though there are passages of Scripture that allude to God bringing disaster upon humans (Isaiah 45:7), we have to interpret those Old Testament passages in light of Jesus, who is our best clue to God's character. Yes, God allows calamities and innocent suffering, but can we picture Jesus planning a child's murder and then making sure it happens? I don't think so.

The Shack's account of the problem of evil and suffering goes a long way toward assuring me of God's goodness. Along with the author of *The Shack*, I believe in a God who limits his power for the benefit of our free will, not in a God who secretly plans the murder of children. Why? Not because it gives me comfort but because it fits with the story of Jesus, who perfectly reveals God's character.

AN ALL-OR-NOTHING PROPOSITION?

I'm not convinced, however, that God never violates human free will. I agree that God cannot unilaterally stop all evil without at the same time stopping a lot of good. God has given us the awful gift of free will and has not taken it back—yet. He has his reasons and will reveal those to us someday. But in the meantime I don't see it as an all-or-nothing proposition. Sometimes God appears to override free will. For example, Paul was traveling to Damascus to kill Christians when God knocked him off his horse and revealed himself to Paul so powerfully that this evil man could not go on. Paul was converted into an apostle of the Lord Jesus Christ (Acts 9). It seems to me that God vio-

lated Paul's free will. But perhaps the author of *The Shack* would say that God powerfully persuaded Paul without violating his free will. Nevertheless, I'm not at all sure that we can say God doesn't sometimes force people to do good. However, I'm confident the God of Jesus would never coerce someone to do evil.

I also wonder how God could finally bring an end to evil and redeem this world without violating some wills. I agree with the author of *The Shack*, though, that God normally does not make people do good or evil; he only allows evil and encourages goodness. That's the picture of God I get from looking at Jesus.

3

Is God Really
a Family of Three?

SEVERAL ASPECTS OF GOD'S APPEARANCE in *The Shack* will inevitably shock, confuse and perhaps dismay some readers, especially those steeped in traditional Christian doctrine—the official teachings of conservative Catholic and Protestant churches. I grew up in a church that was not all that big on doctrine; we reveled in feelings and emotions. But we knew the broad outlines of what most Christians believe. I remember, for example, a school friend who was a member of a church that was outside of mainstream Christianity. It teaches God is "three separate personages." To us that sounded like the heresy of tritheism—belief in three gods.

Other friends belonged to a fringe Pentecostal church that denied the Trinity. Their church taught that Jesus is the Father, the Son and the Holy Spirit. They believed that God sometimes appears as Father, sometimes appears as Son and sometimes appears as the Holy Spirit, but God is not simultaneously all three. And when God appears in

human form, he is Jesus. To us that sounded like the heresy of modalism: Father, Son and Holy Spirit are three modes of God, who is one person.

We knew what we didn't believe, but we weren't always sure what we did believe. And as I grew older I realized that I had been taught many different views of God in my church, and some of them contradicted each other and the Bible. Some of my Sunday school teachers verged close to tritheism while others verged close to modalism. But our church officially believed the traditional doctrine of the Trinity established at the Council of Nicaea in A.D. 325, which teaches that God is one divine substance and three distinct persons—one what and three whos.

PORTRAYALS OF GOD

I'm sure many readers find *The Shack*'s portrayal of God a bit startling. It has caused many conservative pastors and theologians to reject the book as heresy. But I don't agree. After careful reflection I've decided it is essentially biblical, orthodox and even quite helpful in picturing that which cannot be pictured. However, I also want to warn against possible misinterpretations and a few flaws. *The Shack* is not a book of systematic theology or orthodox doctrine; it's a story—like Jesus' parables—meant to convey a message about God. In his parables Jesus pictured God as a woman looking for a lost coin, as an absentee landlord who sends his son to check on the tenants, and as a shepherd looking for a lost lamb. Are these pictures of God heretical? Only if we take them too literally. So though we take *The Shack* seriously, let's not take it too literally.

We will begin our examination of *The Shack*'s depiction of God with the most basic stuff—who and what God is. Then we'll move on

to details. Along the way I'll mention facets that I think are biblically and theologically correct, and others that may be misleading.

We all want to know what God is like. The Bible gives us many pictures of God. There's

- Yahweh (sometimes mistransliterated as "Jehovah") the warrior God of the Old Testament

- the loving Shepherd of Psalm 23

- Wisdom personified in Proverbs

- the Angel of the Lord, who appears to people throughout the Old Testament and seems to be God himself

- The Father of Jesus Christ, who is also our Father (in a different sense)

- the many faces of God in Jesus' parables, including the father waiting for his prodigal son

- the Spirit who moved across the face of the waters in the Genesis creation story, the dove that descended on Jesus at his baptism, the tongues of fire resting on the disciples on the Day of Pentecost, and the "comforter" or "advocate" sent by Jesus

- the returning king of Revelation, who comes to earth to defeat God's enemies and establish his eternal kingdom

These are just some of the biblical portrayals of God. Traditional theology has tried to unify these into a few basic concepts. Sometimes philosophy has influenced that effort in ways both good and bad. But the French mathematician and Christian thinker Blaise Pascal helpfully notes that the God of the philosophers is not the God of Abraham, Isaac and Jacob. I'm sure he was thinking about some of the unhelpful portrayals of God in Christian theology. Ac-

tually, the Bible only twice says "God is" something: "God is Spirit" (John 4:24) and "God is love" (1 John 4:8, 16). I think it is best to begin with such clear statements and allow them to govern our thinking about God.

GOD AS LOVING SPIRIT

We will therefore begin with God as loving Spirit and then move on to other ways God is identified in Scripture. These biblical definitions of God lie behind much of *The Shack*'s portrayal of God. For example, God explains to Mack that love, which God is perfectly, cannot be alone. Love requires relationship. But if God is one solitary being, he could not be perfect love within himself. Did God create the world to give himself something to love? Creation, then, wouldn't be the free act of God, because God needs the world. And if God's creative act isn't free, it isn't a work of grace. Ultimately, the world would limit God.

Instead, God's love implies that God is more than one lover. This idea, which is biblically and theologically sound, is basic to *The Shack*. Papa, Jesus and Sarayu eternally love one another.

Second, *The Shack* strives to do justice to the biblical truth that God is spirit. By *spirit* I do not merely mean the third person of the Trinity: the Holy Spirit. I mean that just as God's very nature is love, so his very nature is spirit. *The Shack* expresses this seemingly abstract biblical truth when God says to Mack "I am a verb" (p. 204). Let's explore what this means.

Too often we think of God as an object. *The Shack* portrays God as three distinct persons. But behind the imagery God is "alive, dynamic, ever active, and moving" (p. 204). In other words, God cannot be pinned down like a dead butterfly in a display box. This is one

way of saying God is spirit. Unlike created things, God cannot be measured, dissected, analyzed, defined or controlled. Yes, God is personal. But not in the same way a human is personal. A human being is also an object.

God as spirit is central to *The Shack*'s message about God. Mack experiences God as a jolly African American woman, as a friendly carpenter and as an ethereal Asian female. It might be tempting to think God is literally those beings. The author is careful to deny that; these are only appearances of God to Mack—like the images of God in Jesus' parables.

What is God behind the appearances? Spirit and love. A dynamic, loving community that transcends all our earthly categories. We will never be exactly like God, but because we are created in God's image and likeness, we too can begin to experience loving community with God and others.

God is not at all like our common conceptions of God. In his essential being, God is not like Gandalf of *The Lord of the Rings* or Morgan Freeman's character in the movie *Bruce Almighty*. In spite of a seminary education, Mack, like many of us, liked to think of God either as a sentimental, grandfatherly figure or a harsh and punitive judge. *The Shack* intends to correct our folk images of God and replace them with more biblical images. Unlike most of our projections of God (for example, our ideal parent projected into heaven), in himself God is free from all such human characteristics.

UNFATHOMABLY GREAT AND GOOD

But doesn't *The Shack* picture God in his own being as human—even as three humans? A careful reading of the book belies that interpretation. The book carefully informs us that God is not like those ap-

pearances, except in terms of his character.

So, to be fair we have to recognize that *The Shack* does not portray God's divine nature as being like human nature. God tells Mack, and us, "I'm not who you think I am" (p. 96). God is greater than we can imagine. Furthermore, God says, "By nature I am completely unlimited, without bounds" (p. 98).

Some readers, including skeptical and overly critical theological scholars, will no doubt miss these clear and frequent admonitions to Mack. William Young goes out of his way to deny that his portrayal of God as three separate human beings is an accurate presentation of God's true being. God is not human—except through the incarnation of the Son of God in Jesus Christ. God is transcendent. God is spirit. A verb. Wholly other than any creature. Nothing could be clearer in *The Shack*. And that's right and good. After all, the Old Testament book of Isaiah tells us that God's ways are not our ways and his thoughts are not our thoughts (Isaiah 55:8).

This doesn't mean the portrayal of God in *The Shack* is not true or helpful. Far from it. Young clearly wants to change our image of God. He wants us to stop thinking of God as a man with a long, white beard, sitting on a throne and waiting for us to do something wrong so he can judge us. Alternatively, neither is God a grandfather figure whose love for us is so blind that he forgives us no matter what we do. The author wants us to know that those common images of God are wrong.

On the other hand, God is not so different that we can't have a personal relationship with him. William Young wants us to believe that God, though wholly other than us, cares deeply for us. God suffers with us and for us. He died a cruel execution in order to free us from evil. In other words, the God of *The Shack* is both unfathomably great and good. The moment we think we've captured God in a

human image, we should realize he is far greater than that. But the moment we think God is too great to relate to, we should realize he is far too good to leave it at that.

So, what can we know and understand about God according to *The Shack?* The novel's portrayal of God is about his character, not his divine nature, which is beyond comprehension. Mack resents God and doesn't trust him because of serious misunderstandings of who God is and what he has to do with evil. God appears to Mack in the form of a black woman, a young carpenter and a wispy Asian woman in order to reveal his true character. And this changes Mack's ideas of God: "None of his old seminary training was helping in the least" (p. 91).

A GREAT MYSTERY

According to *The Shack*, God is a community of three distinct but never separate persons. God is one being but three persons inseparably bound together in perfect love. If Mack is like many American Christians, even seminary-trained ones, he probably thought of God as one person with three visages or ways of appearing. Or perhaps as one person with multiple facets of personality. When the ancient church father Augustine wrote *On the Trinity*, he elevated the oneness of God above the threeness and relegated the threeness to functions. For Augustine and many Western theologians thereafter, God's triunity is comparable to human memory, understanding and will—three distinct functions of a single personal being.

The Shack takes a different approach. It begins with God's threeness. First, God appears to Mack as "a large beaming African-American woman"—Papa, or the Father. Then God appears to Mack as "a small, distinctively Asian woman"—the Holy Spirit. Then God ap-

pears to Mack as a Middle Eastern man "dressed like a laborer, complete with tool belt and gloves"—Jesus. But these three make abundantly clear to Mack that although they are three distinct persons, they are also one. One God.

Like many of us, Mack wants to understand the mystery of God's oneness and threeness. When he asks them, "Which one of you is God?" they answer in unison, "I am." That's significant, of course, because in the Old Testament God identified his name as "I am." The message is that all three are equally God. So Mack observes, "There's that whole Trinity thing, which is where I kind of get lost" (p. 100). God the Father patiently explains, "We are not three gods, and we are not talking about one god with three attitudes, like a man who is a husband, father, and worker. I am one God and I am three persons, and each of the three is fully and entirely the one" (p. 101). The author of *The Shack* seems to embrace what is called the "social analogy" for the Trinity, which pictures God as a community united beyond anything we can experience in community. Mack is bewildered, and God responds that this is a mystery humans will never fully comprehend.

But God doesn't leave us hanging. William Young believes it's important for us to picture God as a loving community of divine persons. Without community, love and relationship would not be part of who God is. God tells Mack, "All love and relationship is possible for you *only* because it already exists within Me, within God myself. Love is *not* the limitation; love is the flying. I *am* love" (p. 101). Clearly Young doesn't want us to dismiss the Trinity as nothing more than cosmic numerology and an impenetrable mystery. It *is* a mystery because there's nothing like it in our world. But it isn't a dark mystery. On the basis of God's self-revelation to us in Jesus Christ and Scrip-

ture, we can know something about it and live accordingly. That's God's whole plan for us.

CIRCLE OF LOVE

According to *The Shack*, God is a "circle of love." There is no hierarchy or power struggle within God. Hierarchy is a human construct and a result of the fall of humanity into sin. When Mack asks if there's a "boss" among the three persons of the Trinity, God acts somewhat bewildered. Mack asks if the three persons have a chain of command. Jesus responds, "Chain of command? That sounds ghastly!" (p. 122). God lectures Mack (and us) about power: "Once you have a hierarchy you need rules to protect and administer it, and then you need law and the enforcement of the rules, and you end up with some kind of chain of command or a system of order that destroys relationship rather than promotes it" (pp. 122-23). God, Young tells us, has within himself no final authority or hierarchy, only love. Domination is a sign of our fallenness and not part of the order of love that God intended, and still intends, for us. God wants humans to be in face-to-face relationship with all others by joining the circle of love of the Trinity (p. 124).

The Shack will not sit well with some Christians who are "law and order" people of God. Some years ago a popular evangelist held seminars on relationships that were attended by thousands. According to the evangelist, God wills that humans remain in their place in God's chain of command: husband over wife, father over children, elder over younger and so on. All family dysfunction arises from stepping out of the chain of command. More recently, some evangelical Christians have been arguing that there's a chain of command within the Trinity, with Father over Son and Holy Spirit. And this hierarchy

transfers to human beings, so husbands rule over their wives. For Young, love shapes the Trinity's relationships, not hierarchy. Love also shapes us when we enter into a right relationship with God.

JESUS AND THE TRINITY

The Shack also discusses Jesus Christ and his cross. Although all three persons of the Trinity appear to Mack as human beings, it's clear only one really is human. The Father and Holy Spirit only *appear* to be human, so Mack can better relate to them. The carpenter Jesus, however, is very much a human being as well as God. This confuses Mack, and he's not alone. Many of us find this aspect of God bewildering. *The Shack* takes a stab at clearing up our confusion.

In order to cure the mess human independence created, the Trinity "rolled up our sleeves and entered into the middle of the mess—that's what we have done in Jesus" (p. 99). Things get a little muddled when Papa (the jolly African American woman) tells Mack, "When we three spoke ourself into human existence as the Son of God, we became fully human. We also chose to embrace all the limitations that this entailed" (p. 99). The problem is God's claim that all three persons spoke themselves into human existence. Only the Son became human; the Father and Holy Spirit did not. That's why in the Bible Jesus said that the Father was greater than he (John 14:28).

"Jesus," God tells Mack, "is fully human. Although he is also fully God, he has *never* drawn upon his nature as God to do anything. He has only lived out of his relationship with me" (pp. 99-100). Jesus is a human being as well as God, and because he is human he depends entirely on the Father and Holy Spirit for all his works. In other words, *The Shack* implies, contrary to our human declaration of in-

dependence from God, the truly human Jesus lives in total dependence on God. Without discarding his divinity, Jesus scaled it down, so to speak, in order to live as a true human person.

Theologians call this the kenosis of the Son of God. *Kenosis* is a Greek word for self-emptying, humbling. In other words, the eternal Son of God, who is equal with the Father, gave up his attributes of glory for the sake of living a truly human life. Of course, *gave up* does not mean discarded. It means something more like moved from active to passive mode. Jesus chooses not to use those attributes because we can't, and he is our brother by choice. Theologians who take this approach to Jesus and the incarnation appeal to Philippians 2:5-11, which says that the Son of God did not think equality with God a thing to be tenaciously held on to, but he "emptied himself," taking the form of a servant. Not all Christian theologians interpret the incarnation this way, but clearly Young does. God takes us so seriously he humbles himself for our sake (and we should do the same for others).

Young also makes a theological mistake when he has God tell Mack that all three persons were there *together* on the cross as Jesus died (p. 96). Mack responds to God, "Now wait! I thought you *left* him—you know—'My God, my God, why hast thou forsaken me?'" God replies, "You misunderstand the mystery there. Regardless of what he *felt* at that moment, I never left him" (p. 96).

This is only partially true and potentially very misleading. The Father *did* "turn his back" on the Son when the sins of the whole world were laid on him as he died on the cross. Jesus' cry of dereliction was not merely an expression of a misperception of God's presence or absence. God the Father had to turn away, figuratively speaking, in order for the Son on the cross to experience the weight of sin

for us. That was how the cross worked our salvation: God in the person of the Son took our place in death and suffered our punishment so that we don't have to. Perhaps Young is trying to communicate that the Father and Holy Spirit are not cut off from Jesus in his incarnation. But the Father most certainly did not die. The author's affirmation comes close to the heresy called *patripassianism*—the suffering and death of the Father. At the same time it comes close to denying the substitutionary atonement.

A Moving Portrayal

Having said that, I consider these flaws relatively minor in what is otherwise a superb and moving portrayal of the character of God. The God of *The Shack* is a community of perfect love who wants to share that relationship with humans. He, or they, want to draw us into that love if we will only allow it. The God of *The Shack* cannot act apart from love (p. 102) and does not wish to dominate, control or overpower us. The God of *The Shack* is a comprehensible mystery, an oxymoron to be sure. But it's true to the way God is portrayed in the Bible—beyond our full comprehension but also accessible to our understanding because of his loving action of stooping down to us in divine revelation.

We live in a time when many Christians either fear God or see him as their "good buddy" or heavenly slot machine. The God of *The Shack* is ultimately and finally personal in the very best sense of the word. God is not an object that we somehow control but a subject (or three subjects) who desires to heal our wounds and draw us into his circle of love.

4

Is God in Charge but Not in Control?

I CAN'T BEGIN TO COUNT THE TIMES I've heard that "God is in control" or "God knows what he is doing" when something terrible has happened. Biblically literate people often quote one Bible verse in particular to support their belief that whatever happens is God's will: "For I know the plans I have for you, says the LORD, plans for welfare and not for evil, to give you a future and a hope" (Jeremiah 29:11). Once they adopt this position, of course, they have to believe that whatever happens, however tragic, is not evil but good.

But when an awful calamity strikes or someone does something horribly evil we wonder, *Where is God?* It's a natural question because the human heart can only take so much pain. This is the burden of *The Shack*—to ask and answer that question. Where was God when Missy was kidnapped and murdered?

EVIL ABOUNDS

This kind of horror is not all that uncommon. On September 28,

2008, the television show *48 Hours* aired an hour-long episode about two boys kidnapped and sexually abused by a predator. One was only eleven when he was violently abducted and then held bound and gagged for months as his captor brutalized him. It was four and a half years before he was rescued. And he was fortunate. Many are found dead; some are never found. The horror is unthinkable. The families are shattered.

The author of *The Shack* wants us to think about God's role in such atrocities. He could have written about the Holocaust or genocide in an African or eastern European country. But he chose the murder of an innocent child so we could not possibly think, *Well, sometimes people bring it on themselves.* We should never say this in the face of any tragedy, but sometimes we try to soften the blow when our minds can't fathom the inhumanity. Young wants us to face the worst pain we can imagine so we can find out how God is involved.

I once knew a seminary professor who lost his faith in God when his little boy died of a disease. By all accounts the professor was a devout man with strong faith in God. He taught a generation of ministers and no doubt told them that God is in control. (I don't know this for sure, though it's so common that I presume he did.)

I knew another seminary professor who taught his students that God is the all-determining reality and whatever happens is according to God's plan. But when his boy died, he experienced a dramatic shift in his thinking about God, evil and suffering. I can't blame the first professor. If my child died, I might lose my mind, to say nothing of my faith. But I agree with the second professor's change of heart and mind.

Nonetheless, today there is a new wave of belief in absolute, meticulous providence of God among young Christians. For answers to these perplexing questions they are turning to a theology that says "behind a frowning providence / God hides a smiling face" (from an eighteenth-century hymn). In other words, sometimes when everything seems black all we can see is God's dark and frowning face, but behind the scene God is smiling because he knows our pain's good purpose and is its ultimate cause. Thousands if not millions of young people are embracing that view of God and evil. I wonder what they will think if Mack's tragedy ever happens to them?

The Shack is not clear about what Mack was taught in seminary, but I can guess it was some version of the meticulous providence of God. It's taught in many, if not most, conservative Christian seminaries. And that's because the Bible seems to teach it. I say *seems* because with Young I'm not convinced the Bible really teaches this. But I'm not sure *The Shack's* version of God's providence is without flaws either. So I will examine the book's view of God's role in tragic events to see how biblically and theologically sound it is.

THREE VIEWS OF GOD AND EVIL

First, we will look at the main Christian views of God's providence and the problem of evil. In a nutshell the problem of evil asks, If God is all powerful and all good, why is there evil in his world? A traditional view going back to the church father Augustine is that God is the all-determining reality and nothing happens apart from his plan and control. In this view God positively plans and then renders certain every event without exception. According to Reformer John Calvin, God even foreordained Adam and Eve's (and our) fall into sin. This view does not say that God directly causes evil, but that

God plans for evil and renders it certain by withdrawing his protective power that keeps evil at bay. For people who think this way, the biblical story of Job is representative. God removed the protective hedge around Job and allowed the Accuser (Satan) to plague him.

But even if God does not cause evil, he plans it and makes sure it happens. Evil is part of God's will and is necessary for some greater good, which may be beyond our comprehension. Many people find great comfort in this when evil strikes. After all, if a tragedy is part of God's great plan, then it is not meaningless. Otherwise, it would be.

A second view held by many Christians throughout the centuries is that God limits his control to allow for human free will. It's part of God's plan to let us choose to love him or not. When evil occurs, however, it's our doing and not his. He reluctantly allows it because to interfere would be to take our freedom away. This doesn't mean God never interferes to stop evil; just that he doesn't always stop it. Why? We don't know. Perhaps because God depends on us to limit evil and to empower him by praying. But in any individual case we can't be certain. All we can know for sure is that evil is always against the will of God.

Process theology, the third view, says God is not all-powerful and therefore cannot stop all evil. Thus evil events are not his fault. This view falls far outside mainstream Christian thought and seems to have been invented during the twentieth century to rescue God's reputation in the face of genocide and other horrors of history. Most Christian theologians reject process theology because it robs humans of hope for the ultimate triumph of God (and good over evil). However, many Christians, including more than a few evangelical laypeople, have been influenced by a form of process theology

through books like Harold Kushner's *When Bad Things Happen to Good People* (1993). Kushner says, more or less, bad things happen because God can't do anything about it. This is the opposite of the Augustinian belief that God controls everything.

THE SHACK AND THE PROBLEM OF EVIL

So what is *The Shack*'s answer to the problem of God and evil? It's not simple. It takes some deep thinking and makes allowance for some degree of mystery.

The story begins by hinting that Mack has lost his full faith in God. We don't know exactly why, but he is unsure of his faith. The book hints that his seminary education left him with more questions than answers. Deep inside he's not so sure what he really believes. Nevertheless, he is going through the motions of living a Christian life. Isn't that the condition of many of us? If we're honest, we have to admit it is much of the time.

Then comes the kidnapping and murder of Mack's precious little girl, which breaks his fragile trust in God almost completely. Over the following months he comes to resent God and questions his goodness. But God graciously intervenes and invites Mack into a conversation in which God reveals his character to Mack.

As God interacts with Mack the main topic of conversation is evil and innocent suffering. It takes Mack a long time to "get it." God's answers aren't easy to understand. Most of us, including Mack, are conditioned to think certain ways about God and evil. God either has everything or nothing to do with it. We might know enough to mutter something like God does in the movie *Time Bandits*. When asked why he allowed evil, God says pensively, "I think it has something to do with free will." That's about all most of us can say. But the

author of *The Shack* goes much deeper into the subject. And though he seems to disagree with the three main views discussed earlier, he comes closest to the self-limiting God who allows evil because of our free will.

Deep into his conversation with God Mack asks, accusingly, whether God could have prevented what happened to Missy. That's the big question, and God doesn't dodge it. "Could I have prevented what happened to Missy? The answer is yes" (p. 222). Oh, oh. We gulp with Mack. So now what? Is God to blame? No, we are—all of us together. God explains that he (the three divine persons) has limited himself: "We have limited ourselves out of respect for you" (p. 106). God explains that "he doesn't stop a lot of things" he could (p. 164). The God of *The Shack* is not "the fixer." He doesn't interfere to prevent every misuse of free will, because he respects our freedom and our choices. Mack demands, "So why don't you fix it?" (this world that has gone so far astray from God). God responds, "Because we gave it to you." "Can't you take it back?" Mack queries. "Of course we could, but then the story would end before it was consummated" (p. 145). Mack stares blankly at Jesus, who is saying these things. Patiently, Jesus explains:

I've never taken control of your choices or forced you to do anything, even when what you were about to do was destructive or hurtful to yourself or others. . . .

To force my will on you is exactly what love does not do. Genuine relationships are marked by submission even when your choices are not helpful or healthy. (p. 145)

That begins to answer why there is so much evil and innocent suffering in God's world. Out of love God limits himself, ties his hands,

as it were, for our sakes. He does not wish to control us anymore than a perfectly good, loving parent tries to control a maturing son or daughter. Guide, yes. Control, no.

I'm not at all sure, however, that true love never forces others to do anything. I think *The Shack* goes too far in regard to God limiting himself for the sake of our free will (see pp. 22-26). It leans a little too close to deism (which denies God's involvement in history) or process theology (which implies God is too weak to overcome evil). But in at least one place the book suggests that God has intervened to stop much evil, but humans don't know about it (p. 190). This seems to contradict what Young says in many other places.

Then comes the real shocker. Right after saying God doesn't force us, Jesus tells Mack that God is submitted to us. We don't hear that very often from pulpits! Mack asks, no doubt with wide eyes, "How can that be? Why would the God of the universe want to be submitted to me?" "Because we want you to join us in our circle of relationship. I don't want slaves to my will; I want brothers and sisters who will share life with me," God replies (pp. 145-46). That's where *The Shack*'s version of God and evil goes farther than the traditional free-will explanation of evil. God not only limits himself, says *The Shack;* he lets down his control and gives it over to us so that we love or hurt him!

I have some doubts about this. I think it is over the top when Mack says, "God, the servant. . . . It is more truly God, my servant" (pp. 236-37). There is some truth in it, but surely it could be expressed in a better way. The God of the Bible loves us and seeks our good, but he is nevertheless always our Lord and Master (always in a loving, benevolent way). He is our God, and we owe him worship and submission.

So part of the explanation of the presence of evil in God's good creation is God's self-limitation for the sake of our free will. According to *The Shack* divine interference to stop all evil and suffering is not an option for God. Why? This is a mystery. God tells Mack it's because of "purposes that you cannot possibly understand now" (p. 222). In other words, God has a plan, and it involves respecting our freedom, but why God sometimes interferes is something we cannot know. So God could have prevented what happened to Missy. He had the *power* to do it. But for certain unknown reasons, in this particular case God could not step in. Apparently God abides by rules known only to himself.

Why does God's self-limitation and our free will result in horrendous evils and inhumanities that cause even God to suffer? What has gone wrong? *The Shack* paints a pretty dark picture of our world. God gave the world to us, and we messed up, big time. We declared our independence and decided we know good and evil better than God. Theologians call this the sin of pride or "idolatry of the self." We usurp God's place in our lives even though we're totally unqualified to play that role. As Blaise Pascal said, we are kings sitting on crumbling thrones holding broken scepters. We are finite and fallen. Created in God's own image and likeness, we were given dominion over creation. But in rebellion against our Creator, we destroy everything around us, including ourselves.

God reluctantly responds to our declaration of independence, "If you want to do your own thing, have at it" (p. 149). It sounds cold and cruel. But what else could God do? What else can a longsuffering parent do with an adult child who has adult rights and is misusing them to great harm? Of course, this doesn't mean God won't work with us. The whole point of *The Shack* is redemption; God is redeeming this rebel world. But he won't override our free will, yet.

GOD'S PLAN FOR EVIL

So where is God when horrible evils happen? Is he simply watching it happen? Does he shout commands at us but refuse to get involved? Hardly. *The Shack* explains that God has a plan to redeem the world by bringing good out of evil. God tells Mack, "All things must unfold, even though it puts all those I love in the midst of a world of horrible tragedies" (p. 191). In other words, there's a reason why God can't step in now and unilaterally end evil, but he will when the proper time comes. "This life is only the anteroom of a greater reality to come. No one reaches their potential in your world. It's only preparation for what Papa had in mind all along" (p. 167).

William Young is telling us that there is hope; God has not left us to our own devices. First, God makes it up to innocents who suffer. We see Missy romping and playing and enjoying heaven. She's at peace. We get the impression she wouldn't come back to earth if she had the option. The joys of heaven make up for all the pain of this world. Second, God brings good out of evil without making evil good. "Papa weaves a magnificent tapestry. Only Papa can work all this out, and she does it with grace" (pp. 176-77). And "just because I work incredible good out of unspeakable tragedies doesn't mean I orchestrate the tragedies" (p. 185). God doesn't orchestrate or control everything that happens, but he is in charge of all of this world. He lovingly and powerfully weaves a beautiful tapestry by bringing something good out of evil, but this doesn't lessen the enormity of the evil.

God explains to Mack, "Nothing is as it should be" (p. 164). And it's our fault, not God's. God has the power to control us so that we could not do evil, but for reasons beyond our comprehension he cannot yet do that. It has something to do with God's great plan to

draw as many as possible into his circle of love. And love is not co-ercive. In the meantime, God takes the evil that we do and uses it for good.

So, along with those who believe in God's meticulous providence or detailed control of human actions, *The Shack* says that God guides creation and nothing can happen without his permission. But, contrary to this view of providence, though God is in charge, he doesn't control everything. Humans have free will. Evil is completely our doing and not part of God's plan. But again, along with meticulous providence, *The Shack* affirms that God can and always does bring good out of evil.

Though similar to the theology of providence that emphasizes free will and God's self-limitation, *The Shack* argues that God will work out his plan in spite of us and, if necessary, even without us. But it too affirms that God does not force humans to do evil.

With process theology *The Shack* says God is good but does not exercise power to halt evil. It unites God's goodness with God's greatness. God's greatness is his goodness. But against process theology *The Shack* says God will triumph over evil. However, along with process theology, it tells us God will not force his will on anyone.

BIBLICAL PORTRAITS OF GOD

I believe *The Shack*'s story of God's involvement in our world of evil and suffering is both biblical and reasonable, even if it pushes the envelope in both cases. And I find great comfort in it.

How does the God of *The Shack* stack up to the God we find in the Bible? Let's be clear, the Bible provides multiple portraits of God. On the one hand, the God of the Bible seems to be very powerful and controlling. For example, the Lord says:

I form light and create darkness,

I make weal and create woe,

I am the LORD, who do all these things. (Isaiah 45:7)

And Genesis 45 indicates that God orchestrated Joseph's sale into slavery so Joseph could become a government official in Egypt and rescue his people during a time of famine. So some biblical authors apparently attribute everything that happens to God.

On the other hand, when Moses asks to see God's glory, God passes before him and proclaims in part:

The LORD, the LORD, a God merciful and gracious, slow to anger, and abounding in steadfast love and faithfulness, keeping steadfast love for thousands, forgiving iniquity and transgression. (Exodus 34:6-7)

And through the prophets the Lord repeatedly implores sinful people to turn from their evil ways, which God hates:

Come now, let us reason together,

 says the Lord:

though your sins are like scarlet,

 they shall be as white as snow;

though they are red like crimson,

 they shall become like wool.

If you are willing and obedient,

 you shall eat the good of the land;

But if you refuse and rebel,

 you shall be devoured by the sword;

for the mouth of the Lord has spoken. (Isaiah 1:18-20)

And in the prophet Ezekiel we read, "I have no pleasure in the

death of anyone, says the Lord God; so turn, and live" (Ezekiel 18:32).

The picture of God in the New Testament centers around Jesus, who is God in the flesh. Surely this revelation is the key to interpreting the rest of the Bible's story of God. The God of Jesus is a loving heavenly Father who wants the best for his creatures: "For God so loved the world that he gave his only Son, that whoever believes in him should not perish but have eternal life" (John 3:16). God doesn't want anyone to face eternal punishment but desires all people to repent and know him (1 Timothy 2:4; 2 Peter 3:9). Thus Jesus wept over Jerusalem because of its people's unbelief (Luke 19:41-44).

Reconciling these various portrayals of God is not always easy. But as a Christian, I believe it's wise to draw my view of God primarily from Jesus and interpret all other portrayals of God in that light.

The Bible implies throughout that God gives us free will and allows us to do great evil, which runs counter to his will. Following Adam and Eve's disobedience in the garden (Genesis 3), God genuinely grieves and later regrets having created humans (Genesis 6:6) because of their evil ways. This makes it difficult to interpret evil as part of God's plan. Has God orchestrated the very thing that causes him to regret making people? The Bible attributes evil and inhumanity to humans. And the New Testament (e.g., Romans 1) clearly places the blame squarely on humans shoulders.

Is it reasonable to believe that God is behind all the terrible things humans do? Since God protests and warns against all evil behavior, does it make sense that he also causes it to happen? Jesus taught his disciples to pray that God's will be done on earth as in heaven (Matthew 6:10). What's the purpose of such a prayer if God's will is already always being done?

To me *The Shack* is biblically correct and has reason on its side when it portrays God as genuinely shocked and in grief over human sin. Overall, biblical revelation does not teach that God is secretly orchestrating evil. However, evil cannot escape God's overarching control of history. God decides what will become of evil. But it is better not to say that God is in control, because that is misleading. After all, evil exists even though God does not cause evil. It is better to say, as does *The Shack,* that God is in charge but not in control.

Any other portrayal makes God seem morally ambiguous or powerless at best.

5

What's Wrong
with the World and Us?

WHO HASN'T ACCUSED SOMEONE OF being too pessimistic? I hear it all the time. People, especially my wife, accuse me of that.

I usually just respond that I'm a realist. I see the world as one great tragedy punctuated by occasional random acts of kindness by God and people. On the other hand some people are so heavenly minded they're no earthly good. That usually means they're too spiritual and perhaps too optimistic. Nobody has ever said that about me. But I've said it about quite a few people.

Pessimistic optimism or optimistic pessimism—these oxymorons accurately describe *The Shack*'s attitude toward fallen human beings and their world. It's a story of tragedy and redemption—just like the Bible. *Tragedy* doesn't refer to only one or two or three awful events; it refers to the whole messed-up world. And *redemption* doesn't refer only to a few events in which God rescues people from despair; it refers to God's action for all people and the whole world.

OPTIMISTIC REALISM

My view of people and the world is similar to *The Shack*'s. Things are a mess. There's very little hope if we're left to ourselves. This perspective isn't because bad experiences have jaundiced me. It's based on the biblical story about us and our world. Nevertheless, I claim to be an optimistic realist because against all the evidence and based on what I read in the Bible (and occasionally experience in glorious moments of God's special mercy) I view the world as not entirely hopeless. God is at work in it and someday is going to heal it.

Romans 8:18-25, for instance, clearly promises a future in which the sufferings of this world will pale in comparison with the glory that God will reveal to us. Paul, the author of Romans, talks about God's intervention to free the whole world from bondage to decay. A kind of resurrection of the cosmos! My optimism is in God, not in myself or my fellow human beings. That's one reason I resonate with the story of *The Shack*. It's very realistic about humanity and very optimistic about God, just like the biblical story.

Anyone who takes a dim view of pessimism should take a look at Psalm 14:

> The fool says in his heart, "There is no God."
>> They are corrupt, they do abominable deeds,
>> there is none that does good.
> The Lord looks down from heaven upon the children of men,
>> to see if there are any that act wisely,
>> that seek after God.
> They have all gone astray, they are all alike corrupt;
>> there is none that does good,
>> no, not one.

Don't be fooled by the first verse; the passage is about *everyone*, not just atheists. In light of the whole passage, the fool in the first verse is you and me!

Okay, so that's one psalm. Maybe the psalmist was in a bad mood that day. Look at Romans 3:9-18:

> What then? Are we Jews ["we Christians"] any better off? No, not at all; for I have already charged that all men, both Jews and Greeks, are under the power of sin, as it is written:
>
> > "None is righteous, no, not one;
> > no one understands, no one seeks for God.
> > All have turned aside, together they have gone wrong;
> > no one does good, not even one."
> > "Their throat is an open grave,
> > they use their tongues to deceive."
> > "The venom of asps is under their lips."
> > "Their mouth is full of curses and bitterness."
> > "Their feet are swift to shed blood,
> > in their paths are ruin and misery,
> > and the way of peace they do not know."
> > "There is no fear of God before their eyes."

A pretty dismal picture of us, isn't it?

This too is *The Shack*'s portrayal of us. But it doesn't stop there. Like the Bible it also portrays us as loved by God in spite of what we have become. People looking for signs of hope in a world marked by cruelty and inhumanity should look at Revelation 21:1-4:

> Then I saw a new heaven and a new earth; for the first heaven and the first earth had passed away, and the sea was no more. And I saw the holy city, new Jerusalem, coming down out of

heaven from God, prepared as a bride adorned for her husband; and I heard a loud voice from the throne saying, "Behold, the dwelling of God is with men. He will dwell with them, and they shall be his people, and God himself will be with them; he will wipe away every tear from their eyes, and death shall be no more, neither shall there be mourning nor crying nor pain any more, for the former things have passed away."

A DARK PORTRAYAL

That's the blessed hope offered to us throughout the Bible. But what about now? The focus of *The Shack* is on the here and now, and it's not a pretty picture. A main character of the book is the elusive "Little Ladykiller," who kidnaps and murders little girls. He too stands for Everyman. But don't get me wrong. *The Shack* doesn't imply that every one of us is as bad as the Ladykiller! Not at all. But our whole world and all of us together are caught up in a system that gives rise to Ladykillers, Hitlers and other evildoers. And there's no absolute break between them and us; we're all capable of doing really evil things. Mack's distrust in God is an evil thing even though God understands and helps him.

Many readers of *The Shack* may have trouble with its dark portrayal of humanity. We don't hear many sermons by televangelists about how bad we are. Most sermons from American pulpits aim to boost our self-esteem: God loves and accepts us just as we are. *The Shack* says that also, but first it tells us a darker truth about ourselves. That's what makes the message of God's unconditional love so powerful.

So let's return to the plot of *The Shack* to remind ourselves about the human condition it portrays.

Mack keeps wanting to put God in the dock, so to speak, to stand trial for his crimes. In other words, he judges God for allowing Missy to be kidnapped and murdered. But even more he seems to accuse God of being something less than good in light of all the horrible things that happen in the world. In more than one instance God points the finger back at Mack and all of us as the source of evil: "Papa has never needed evil to accomplish his good purposes. It is you humans who have embraced evil and Papa has responded with goodness. What happened to Missy was the work of evil and no one in your world is immune from it" (p. 165). In a nice way, God tells Mack (and us) that we are all potential Ladykillers. We may never be tempted to such a horrible thing! But we all push God away and do our own thing, and that opens the door to terrible evils of one kind or another. The world is a place that includes Ladykillers because we all have rejected God by declaring our independence from him.

WE'RE IN THIS TOGETHER

The world's problems aren't God's doing. That's one major message of *The Shack*. We like the part about God's goodness. But we may not like the part about our responsibility for evil. It isn't just some elite group of evil people who are responsible for evil. We're all in this together. Even Mack, one of the sweetest men anyone could ever hope to meet. When God tells Mack "you humans have embraced evil" he doesn't mean "some of you humans." He means Mack and you and me. I wonder how many of us caught that while reading *The Shack*? We often see only what we want to see in a book. (Believe me, I know this from teaching university students for twenty-six years!)

How did the world's terrible mess come about? If it's not God's fault, isn't it Satan's, or perhaps Adam's and Eve's? *The Shack* rightly

points the finger back at us and away from those we'd like to blame. God says Mack (and everyone) demands independence from God and then gets angry when he gets it. According to *The Shack* this world is a terrible place "lost in darkness and chaos." Horrible disasters happen even to people God is especially fond of (p. 164). How pessimistic. No, how realistic!

Papa (God) is teaching Mack about the Fall and its effects, original sin and total depravity. These are very unpopular concepts in our culture. But they are biblical and true to experience. The early twentieth-century Christian writer G. K. Chesterton quipped that original sin is the only empirically verifiable doctrine of the Christian faith. Without using these theological terms *The Shack* reveals their truth about humanity.

What has the fall of humanity into sin done to the good world God created? Sarayu, otherwise known as the Holy Spirit, explains to Mack that humans are blind to their place in creation; they have chosen independence and thereby dragged down all of creation with them (p. 132). She tells him that Adam and Eve's choice to disobey God by eating the fruit of the Tree of the Knowledge of Good and Evil (Genesis 3) tore the universe apart. It broke the bond between the spiritual and the physical. Their choice expelled the breath of God, which is a big problem (p. 135). Humanity's declaration of independence from God ruptured creation; at that very moment evil moved in. A curse fell on nature because of what humans did (and still do). We became crooked and corrupted. Nothing will ever be the same.

GOD, FREEDOM AND EVIL

This dismal but biblically accurate picture of the world raises a question. Didn't God create evil? After all, he is the creator of everything,

so it evil exists God must be responsible. *The Shack* corrects that error. Evil, it tells us, is not a thing or a substance, and is not a part of creation. Evil is the absence of the good (p. 136). It has no being, so God did not create it. Whatever has being is created by God, but God didn't create the absence of goodness. This truth goes way back in Christian thought. And it's quite right. Otherwise we would have to attribute evil to God.

The Shack declares that God is not the author of evil, nor is he responsible for allowing us to bring it into existence. But wait a minute! Is it possible for evil to exist if it's nothing but the absence of the good? Perhaps an analogy will help answer this question. Darkness is the absence of light. But darkness exists. Anyone who has been in a cave when the lights go out knows this. Similarly, evil exists even though it has no positive being. It exists as the absence of the good. When God gave us free will he allowed the possibility of evil to enter the good world. When we demanded our own way, God said to us, "Okay, not my will but thine be done." Evil is our responsibility, not God's. And the consequences are unimaginably horrible.

Because of us, nature is under a curse. We abuse nature, and it returns the favor with natural disasters (hurricanes, earthquakes and tsunamis). And we ourselves are so corrupt we continually do evil and have a hard time doing anything good. This is *original sin*—the corrupt nature we all inherit from our ancestors and peers, which makes us do evil things willingly. The Christian doctrine of *total depravity* is related. It's our inability to do anything righteous without God's supernatural help. Our whole being, without exception, is bent and broken. Don't think of original sin and total depravity as germs we catch from others. Think of them instead as both universal birth defects *and* as bad social conditioning. We know how powerful

socialization is; if everyone around us is bent and broken in character, we will be as well.

Original sin teaches that spiritual corruption, which breaks our relationship with God, is universal. We're born with it. It's like a ticking time bomb inside of us, and if we live long enough it will go off in acts of disobedience that reveal our preference for ourselves over God and others. Total depravity teaches that nothing we do by ourselves can restore our broken relationship with God. Whatever "good" we do is always tainted by selfishness and pride.

The Shack is brutally realistic. And it illustrates our fallen preference for power over relationships. God wants a loving relationship with us, but we strive for power over others. Referring to broken relationships, God tells Mack, "It always comes back to power and how opposite that is from the relationship you have with [others]" (p. 149). And "power in the hands of independent humans, be they men or women, does corrupt" (p. 148). The Fall of Adam and Eve involved a power grab by human beings. Independence, individualism and competition resulted from the evil that began with the Fall and continues today. And they destroy relationships of love.

I think *The Shack* misses a beat when Jesus distinguishes between how the fall into sin affects men and women, implying that men are more fallen than women. Mack responds, "I've always wondered why men have been in charge. . . . Males seem to be the cause of so much of the pain in the world" (p. 147). Then Jesus says, "The world, in many ways, would be a calmer and gentler place if women ruled. There would have been far fewer children sacrificed to the gods of greed and power" (pp. 147-48). Do I object to this because I'm a man? No. I object because this contradicts one of *The Shack*'s main points: power corrupts. If women "ruled" they would be as corrupt

as men, and the world wouldn't be any better off!

How did we all get into this situation? Why does it continue? It goes back to humanity's misuse of free will. There's nothing inherently wrong with free will, but when it's misused it opens the door to evil. We misused our free will to declare independence from God. God tells Mack that everything evil flows from humanity's independence from God. Evil, which touches everyone (p. 190), is the chaos that we bring into the world, but God will not allow it to have the last word. Then God reminds Mack that the only immediate cure would be to take away our free will. But God won't do that because he loves us, and "Love that is forced is no love at all" (p. 190).

The Shack tells us that God created everything good out of the overflowing love of the Father, Son and Holy Spirit for each other. God gave humans free will and ordered us not to misuse it—for our own good. We disobeyed God, choosing to know good and evil apart from God. God respected our freedom, knowing that it would lead to all kinds of horrible things. He allowed it because he wants our love and obedience to be free, not coerced. Our independence cursed nature and produced an endless cycle of evil among ourselves. Our relationships are continually broken by power and domination. Ultimately, we are helpless to do anything spiritually good that might begin to restore our relationship with God and others.

Overall, I think *The Shack*'s account of the source of evil in the world is biblically and theologically sound. Of course, people who believe in God as the all-determining reality may find fault with the book's strong emphasis on free will. I, on the other hand, wonder if the book goes far enough.

Several times it says that God foreknew all that would happen when he created the world (see, for example, p. 94). Yet the book at

the same time implies that God took a risk by creating us with free will. But if God knew it all in advance, what risk did he take? And if God knew with absolute certainty what would happen and created anyway, isn't he somehow responsible for what followed? At one point in the book God says he "has a great fondness for uncertainty" (p. 203). Really? How could he be uncertain if he foreknew all that would happen? The book seems to be giving us two messages that are at odds with each other.

Can we resolve this dilemma? I'm not sure, but what if, instead of knowing with absolute certainty, God limited himself to knowing all possible outcomes and was prepared to deal with whichever ones became actual? It's just something to think about.

BAD NEWS AND GOOD NEWS

It's a grim picture. But does it adequately explain the unspeakable acts of the Ladykiller? Why do some of us turn out to be Hitlers and others don't? *The Shack* doesn't answer this question directly. Let's see what we can discern from the story.

When God asks Mack what should be done with the man who kidnapped and murdered his little girl, Mack screams, "Damn him to hell!" (p. 161). I can sympathize, even though I know intellectually that this expression of hate is wrong. So God asks Mack, "Is he to blame for your loss?" Of course he is, Mack answers. God then goes where we don't want to follow. He asks Mack about Ladykiller's father, who twisted his son into the killer he became. Mack damns him too. Then God asks Mack how far back this should go—all the way to Adam? And why stop there? What about God? Since he is the Creator, is he the one to blame? (p. 161). Mack's silence reveals his apparent consent.

What does this reveal about why some people are horribly evil and others are only moderately evil? Is that even true? It gets confusing. *The Shack* seems to be telling us that there's a chain of horrors that leads to people doing horrible things. There's enough guilt to go around. Some people turn out to be monsters because they were raised by monsters, but ultimately it's all a result of humanity's Fall and rebellion, our common declaration of independence from God. Apparently it's a mystery why some individuals become monsters and others are only average sinners. But it doesn't really matter. We all have the potential. As the saying goes, "There but for the grace of God go I." We are all twisted souls; some are just more twisted than others. But given the right circumstances every one of our souls could become twisted to the point of becoming monsters.

God is telling Mack and us that we shouldn't create categories of "especially bad" and "moderately bad" people. Yes, some acts are especially bad and deserve punishment, but all of us are caught up together in this horribly deformed world. Given the right circumstances all of us might be as bad as the worst. From God's perspective we are equally bad, and he is equally concerned for us. Not very palatable, is it? I find it hard to swallow. But I think it's true. The Bible doesn't create categories of evil among people. It lumps us all together and tells us that any "good" we might achieve is nothing to boast of. Only God can justify us and make us right. We have nothing whatever to do with that.

What should Christians think about *The Shack*'s dismal picture of the world and the human condition? Most of us would rather be sunny, optimistic and "have faith in the human spirit." I would. But my own experience resonates with *The Shack*'s portrayal of human beings. Of course, I have seen human kindness at work, but in light

of Scripture I can't give the glory to anyone but God for the good I witness. Whatever good we achieve, the Bible tells us, is God's work in and through us (Philippians 2:12-13). Left to ourselves, we can do nothing good.

Rather than regarding *The Shack*'s portrayal of the human condition as bad news, however, I view it as good news. Though it starts with bad news, it leads to the great news that our Creator hasn't given up on us in spite of our sinful rebellion. And even better, God's Son died for us and plans to redeem us. This is better news than the culture's sunny optimism about "the invincibility of the human spirit." Following Scripture, *The Shack* is realistic and it's hopeful. What more could we want?

6

Does God Forgive Everyone Unconditionally?

MY FATHER WAS A PASTOR FOR OVER FIFTY YEARS, and during that time he accumulated a lot of strange but true experiences. His stories stood out in his ministry because they touched on real-life issues that all people care about. One of his stories touched me deeply every time I heard it.

Early in his pastoral ministry he was asked to visit an elderly woman in a nursing home. She was depressed and spiritually distressed, and needed pastoral counseling. My father went to see her, expecting a routine pastoral call. But the old woman gave him quite a shock. She said that God could never forgive her for what she had done. Pastors don't expect to hear that from an elderly woman in a nursing home! My father assured her that no matter what she had done, God would forgive her. She shook her head sadly and answered that God could not forgive what she had done. Finally, she opened up and told my father that when she was very young and newly married she had poisoned

her father-in-law. She murdered her husband's father.

What should my father have said to her? Well, of course he told her that God would even forgive that if she would repent and trust his Son Jesus, who died for even that sin. Strangely, I don't remember the rest of the story. I vaguely recall that my father left without witnessing the woman's conversion.

The Shack has some very startling things to say about God and forgiveness as well. Though *The Shack* is primarily about God's character, it also says a lot about our response to God. In this chapter we'll explore the novel's account of God's character and what he has done for our salvation. In chapter seven we will examine what we must do to enter into relationship with God.

GOD FORGIVES EVERYTHING

Based on my reading of *The Shack*, I think William Young would say to the elderly woman in the nursing home, "God has already forgiven you for murdering your father-in-law." According to *The Shack*, God is so good that he has already forgiven all humans for everything they have done or will do. God definitely is *not* a sentimental grandfather figure who never disciplines his children. But as love itself, God says yes to us even in the face of our no to him. I fear, though, that a few troubling lines in the book will cause some of us to overlook others that provide some balance.

Some Christians will surely pounce on this startling and perhaps troubling statement by Papa: "In Jesus, I have forgiven all humans for their sins against me" (p. 225). Many conservative Christians see every person they meet as a "sinner on the way to hell." Some of us regard others as unforgiven unless they can describe their conversion to Christ through repentance and faith. Most conservative

churches teach that unless non-Christians get saved, they are destined for hell because of God's wrath.

Young says these notions lead us in the wrong direction. God is not like that, and it's wrong for us to have that attitude toward people he loves (and he loves everyone). This is not a peripheral point; it's central to *The Shack*'s message. The author wants all Christians, but especially conservative Christians, to shift their perspective of God and people. Contrary to what many people think, God is not a harsh judge, demanding that we do something before he will forgive us. Forgiveness is already ours. Is this point biblically and theologically sound?

DISPLAYING THE FATHER'S HEART

Let's begin with *The Shack*'s portrait of God's character. What is God like? What is God's disposition toward us? Clearly, *The Shack* embraces the Bible's theme that God is our parent and treats that as the controlling motif of God's revelation of himself to us. The choice of the name *Papa* for God is telling. It's the author's translation of Jesus' use of *Abba*. *Abba* was a familiar term for one's father in that ancient culture. Calling God *Abba* was revolutionary in Jesus' day; it suggests that God is very much like a daddy who relates to his children with perfect benevolence, not punitive judgment. In *The Shack* this portrayal of God controls all other biblical portrayals. Let's see why.

Papa says to Mack, "The God who is—the I am who I am—cannot act apart from love!" (pp. 102-3). But what's the proof that this is God's all-controlling characteristic and disposition toward us? The cross of Jesus Christ. For Young, the cross is *the* revelation of God's heart, which is self-sacrificing love. Mack says to Papa, "I'm so sorry that you, that Jesus, had to die" (p. 103). (Again, the author seems to

be a little confused here; only the Son died on the cross.) God says to Mack, "I know you are, and thank you. But you need to know that we aren't sorry at all. It was worth it. Isn't that right, son?" Jesus responds, "Absolutely! . . . And I would have done it even if it were *only* for you, but it wasn't!" (p. 103).

Later, Mack reveals that, like many people, because of the cross he found it easier to like Jesus than the Father (Papa). Mack apparently grew up with the idea that the cross was God the Father's way of getting his "pound of flesh" out of humanity in revenge for our sinfulness. That is, Jesus volunteered to take the punishment in our place to assuage the Father's wrath.

Papa corrects Mack's (and our) misconception of what the cross is all about. He tells Mack that Jesus came as one of us to show us who the Father is. Instead, people too often play Father and Son against each other like "good cop, bad cop." If they want to get people to do what they think is the right thing, they appeal to a stern God, which usually is the Father. Then, when they need forgiveness, they turn to Jesus. Papa corrects that common misconception. He tells Mack that on the cross Jesus perfectly displayed the Father's heart: "I love you and invite you to love me" (p. 186).

In other words, the death of Jesus on the cross reveals God's love for us, not just Jesus' love for us. It isn't an expression of God's wrath but *the* ultimate expression of God's love. How? That's a deep and difficult theological question. Theologians have developed many theories to explain what happened on the cross—how Christ's sacrifice saves us. *The Shack* simply says that by means of Jesus' death and resurrection, God is now completely reconciled to the world (p. 192).

Lurking in the background is the idea that Jesus' sacrifice paid the penalty we all owe because of our sin. But the author never lays out

an explanation of how it worked. One possibility is that God needed to demonstrate how seriously he takes sin, so he came into our sinful world in the person of Jesus and suffered the penalty we deserve. As Paul says in 2 Corinthians 5:21: "For our sake he made him to be sin who knew no sin, so that in him we might become the righteousness of God." Just before that, the apostle says "God was in Christ reconciling the world to himself, not counting their trespasses against them" (v. 19).

To Young, this is clear evidence that God's most fundamental disposition toward us is love. God wanted to be reconciled with us, but our sin stood in the way of his holiness. God suffered and died as a substitute punishment for that which we deserve. Now we no longer have to suffer the penalty ourselves. And that means the *whole world*, as Paul says in 2 Corinthians 5!

A popular bumper sticker says "God bless the whole world . . . no exceptions." *The Shack* is saying that God has already done that! Christ died for everyone, so everyone is accepted by God as already forgiven.

IT IS FINISHED

Am I stretching the author's point? I don't think so. Papa and Mack engage in a difficult discussion about Missy's murderer. Understandably, Mack hates the murderer and wants revenge. He wants God to hate the Ladykiller and want revenge too. Papa gently nudges Mack toward forgiveness, saying God wants to redeem the Ladykiller. Mack then blurts out, "I don't want you to redeem him! I want you to hurt him, to punish him, to put him in hell" (p. 224). But God patiently explains to Mack that's not his way. God looks directly into Mack's eyes and says that because of what Jesus did on the cross,

there is now no law requiring God to remember people's sins. Sin no longer causes interference in their relationship. I believe Young thinks of the cross as an objective transaction in which the law dividing God from sinful people is satisfied and is no longer in effect.

Then comes the real shocker. Mack, referring to Ladykiller, says, "But this man . . ." God replies, "But he too is my son. I want to redeem him" (p. 224). Does this mean God hasn't already forgiven him? I don't think so. That's not what Young means. By *redeem* he means something beyond forgiveness; he means having a full relationship with him. Forgiveness does not automatically establish relationship (p. 225). God has already forgiven the Ladykiller, just as he has already forgiven Mack. This is revealed when Papa mentions the men who crucified Jesus—the most horrible crime in history—telling Mack that on the cross Jesus forgave those men. Thus they were no longer in God's debt. He says, "In my relationship with those men, I will never bring up what they did, or shame them, or embarrass them" (p. 225).

According to Young, everyone is already forgiven by God for whatever they do. The cross objectively accomplished divine forgiveness, which does not await proper behavior or even repentance. When Jesus cried out "It is finished!" (John 19:30), he meant it. Reconciliation between God and humanity was a done deal because of God's love. Because God is love.

But what about God's wrath? The apostle Paul says that "the wrath of God is revealed from heaven against all ungodliness and wickedness of men who by their wickedness suppress the truth" (Romans 1:18). There are many references to God's wrath in the Bible, and Mack knows them well. So he asks Papa, "But if you are God, aren't you the one spilling out great bowls of wrath and throwing people

into a burning lake of fire?" (p. 119). God replies that he does get angry; what parent wouldn't? But when it comes to wrath, Papa isn't ready to sign on to that. Instead she says that she—God—is not who Mack thinks she is. God doesn't need to punish people for their sins. Sin is its own punishment because it eats people up from the inside. "It's not my purpose to punish it; it's my joy to cure it" (p. 120).

As if that wasn't strange enough, *The Shack* goes further. Not only does God get angry but not punish us, he is never even disappointed in us! In a strange conversation between Papa and Mack about expectations and responsibilities, God denies having expectations for or even being disappointed with us (p. 206). But this isn't as simple as it seems. Some will pounce on this as evidence that the author is a bleeding heart liberal! Surely his God is a projection of his own softness. However, God explains to Mack that instead of "expectations" he has "expectancy," which is more appropriate to relationships.

I'm getting a bit ahead of myself here, but the God of *The Shack* is not simply dismissing our behavior as unimportant; it matters to him how we act. But putting expectations on us only drives us into guilt and shame. And God isn't interested in doing that. He wants to establish lively, loving relationships with us, in which we want to please him.

The God of *The Shack* is like the waiting father of the parable of the Prodigal Son. God forgives his prodigals—everyone—at great cost to himself. God gets angry but is never disappointed in us (more on this later). He looks forward to and hopes for our full and willing response to his overtures of love. And God respects us. To Mack he says that humans are incredibly wonderful and deserve respect in spite of our terrible, destructive choices. We are the pinnacle of God's creation and the center of his affection (p. 190).

When Young says God respects us, he means, I take it, that God respects our freedom to make choices even when he knows those choices are not in our best interest. He lets us refuse his invitation to enter into relationship with him, which is made possible by the cross. God has already decided for reconciliation; now it is up to us to respond.

Aren't we guilty in God's sight? Not according to *The Shack*. God says to Mack, "Son, this [relationship] is not about shaming you. I don't do humiliation, or guilt, or condemnation. They don't produce one speck of wholeness or righteousness" (p. 223).

This does *not* mean that everyone already enjoys a right relationship with God. Not by any means! Forgiveness does not automatically create relationship. That's where God's respect for us comes into play. Whether we have a relationship with God is now our choice, not God's. But even if we choose against relationship, our *no* to God doesn't cancel out his *yes* to us in Jesus Christ. That's good news indeed—if it's true.

GOD'S WRATH, LOVE AND FORGIVENESS

Is *The Shack*'s picture of God's character and his attitude toward us sinners biblically and theologically correct? Should we believe it and embrace it? Some have rejected it as heresy. I'm not one of them. At the same time I don't buy it completely.

Clearly, *The Shack* is not attempting to account for everything the Bible says about God; in some cases it seems to discount some facets of God in the biblical story. I think the author believes in what is called progressive revelation; the later stages of the Bible and especially the Gospels' stories of Jesus explain most everything else. Jesus' love and the love of the Father he talks about is of utmost impor-

tance in *The Shack*. The parable of the Prodigal Son seems to be the main guide we should use to understand God. The parts of the Bible that seem to conflict with the author's view are qualified in its light of God's love expressed in Jesus.

Is that a good approach to Christian belief about God? It has its risks, to be sure. We have to be very careful not to select from the Bible only what is comforting or desirable. The Bible's message is not meant only to comfort us, and Young admits that. But I wonder if the author has done justice to the holistic portrayal of God arising out of the Bible.

I agree that God is first and foremost love, and that he cannot act apart from love. So whatever God's wrath is, it can't be contrary to his love. I also agree that our best clue to God's character is Jesus, who told his disciples, "He who has seen me has seen the Father" (John 14:9). The heart of God must beat the same as the heart of Jesus, who wept over Jerusalem and told us to love our enemies (Matthew 5:44). Would God tell us to do what he cannot or will not do? In general, I concur with *The Shack* that God is different from the way many of us think about him. He is perfect love with no mixture of hate. His wrath, then, must be a dimension of his love; it is the burning of his love toward those who reject it and live against it.

Having largely agreed with *The Shack* about God, however, let me raise some concerns. First, is it true that God has already forgiven everyone for whatever they have done or will yet do? I think it would be better to say that God, in Christ, has laid the groundwork for forgiveness; he has done everything necessary to forgive us. He has a forgiving heart for all. But forgiveness comes to us only when we surrender to him by laying down our defensive weapons against his love and accept him as our only hope in life and death. Young must have

forgotten what Jesus said after teaching the disciples the Lord's Prayer: "If you forgive men their trespasses, your heavenly Father also will forgive you; but if you do not forgive men their trespasses, neither will your Father forgive your trespasses" (Matthew 6:14).

It would have been better for the God of *The Shack* to tell Mack that he stands ready to forgive but can't until people meet certain conditions. Only faith is required (Ephesians 2:8-9). But *The Shack*'s explanation of divine forgiveness reminds me of the skeptic who was asked if he thought God would forgive him: "To forgive—that is God's business!" It's too automatic to me.

I have doubts too about the claim that God is never disappointed in us, never holds us accountable for our guilt and never punishes us. That's simply not consistent with true love. And the Bible clearly indicates God's disappointment with people. Israel repeatedly disappointed God. In the book of Hosea, for example, God is disappointed with Israel's idolatry just as a wife's infidelity disappoints her husband. What about God's frequent expression of regret for having made people and for having chosen Israel? What about Jesus' disappointment with Peter when he denied him? And how can a biblically literate person deny that God punishes people who do terrible things to others? "It would be better for him [who tempts others to sin] if a millstone were hung around his neck and he were cast into the sea" (Luke 17:2). Throughout Scripture God warns of judgment and punishment for evildoers.

Can't this be reconciled with God's fatherly, loving heart? Yes. *The Shack* is absolutely right in what it affirms about God, but absolutely wrong in what it denies about him. God is love and never acts apart from love. But he also has expectations and is disappointed when we don't, with his help, live up to them. He also punishes the guilty, but

without a vengeful or hateful attitude toward them. All this is consistent with love.

We can appreciate the portrayal of the heart of God in *The Shack* while hesitating to embrace some of its more extreme aspects. It serves as a wonderful corrective to so many wrong ideas about God in our churches and society. The wrathful judge who is stingy with his love and forgiveness is foreign to the compassionate Father of Jesus. But we have to be careful not to throw the baby of God's justice and holiness out with the bathwater of the bloodthirsty God.

A PAINFUL REFUGE

This naturally leads to the subject of hell. What is hell to the author of *The Shack?* He tells us that God does not choose anyone for hell, and implies that God doesn't consign anyone to hell. To illustrate these truths, Sophia, a personification of God's wisdom, asks Mack to judge his five children and choose two to spend eternity in heaven and three to spend eternity in hell (pp. 162-63). It's a gut-wrenching scene. Of course, Mack won't do it. He is, after all, a loving father. What father would do it? And if calling God "Father" means anything, there must be some similarity between our very best understanding of what it means to be a father and God. So, *The Shack* shows us Mack adamantly refusing to carry through on Sophia's request. He begs to go to hell instead of his children. Sophia relents and says, "Now you sound like Jesus. . . . That is how Jesus loves" (p. 163). The context makes clear that this is how God the Father also loves.

This doesn't tell us much about hell, though. We're left to wonder what Young thinks about hell. But it isn't hard to guess. The logic of the story leaves hell as at most a "painful refuge" that God provides for those who stubbornly resist his love. It's possible that the author

doesn't believe in hell at all, but I doubt that. C. S. Lewis provided a picture of hell in *The Great Divorce* that is consistent with *The Shack*'s portrayal of God and humans. Hell is not where God sends sinners, but it's where people who resist God's love ultimately flee because they don't want to spend eternity with God. Hell isn't divinely inflicted torture; it's the torment of living eternally alone with one's own hellish character.

The logic of *The Shack* would seem to require that God never forgets or abandons those who flee to hell. Surely this God would pursue them forever even though there is little chance they'll relent and accept his forgiveness.

A sure mark of truth is that it comforts the afflicted and afflicts the comfortable, those who are complacent in their sin or who are too comfortable about their spiritual state. *The Shack* is wonderful for the afflicted. The comfortable need something else.

7

What Does God Want with Us?

THE SHACK IS A STORY OF EVIL AND REDEMPTION; it powerfully portrays the human condition and God's power to change us. In this chapter we will examine the story's account of sin and evil as well as of salvation. No doubt, most people in our society are not sure what *sin*, *evil* and *salvation* mean. There's little social consensus about them, and churches too often don't clearly teach about them. I suspect that William Young intended to spin a story that teaches what he considers the biblical truth about these realities.

TROUBLING TERMS

Evil is a dirty word in many social circles. We don't often hear politicians, business leaders or entertainers speak about it. When they do, it's usually confusing. Indeed, some years ago President Ronald Reagan spoke of an "evil empire." And President George W. Bush spoke of three nations as an "axis of evil." Both were heavily criticized for

doing so. Does anyone really know what evil is? And how does it fit with an all-good, all-powerful God who created everything and is in charge of the world?

Psychologist and author M. Scott Peck helped recover the word *evil* for use among educated Western people. In his book *People of the Lie* Peck related his own encounters with something he could not find in the *Diagnostic and Statistical Manual of Mental Disorders*, the standard manual for psychiatrists and psychologists. He called the disturbing phenomena he encountered "evil," which caused a stir among his colleagues. But Peck insisted that some people's behavior is so aberrant and damaging that it can only be described as evil; no other term does it justice.

Sin and *salvation* are equally troublesome terms in today's society. Isn't sin just ignorance? Can't we do away with it through social engineering? And salvation brings up images of tent revivals, street corner preachers and door-to-door evangelists. Are these terms useful today?

The Shack doesn't use the words *sin* and *salvation* very much, but their realities make up the meat of the story. Evil happens, sin is the cause, and salvation is the cure. And there's no better way to communicate that than by a rousing good story, as Jesus himself knew!

THE ABSENCE OF GOOD

When we hear of evil it often provokes images of holocausts and acts of terrorism. But what exactly is evil? Is it a substance? Does evil lurk in the dark corners of our world and perhaps the dark recesses of our minds? Why is there evil in a world created by the all-good and all-powerful God of the Bible? As I mentioned earlier, someone has called the problem of evil the "rock of atheism." Many atheists and

agnostics have argued that belief in God is impossible in light of the horrors of history and especially in light of the mid-twentieth-century Holocaust. If God is real, he's responsible for evil, right? What kind of God is that?

The Shack turns to a standard but relatively unknown answer to the problem of evil and puts it in God's own mouth. In the person of Sarayu, God says, "Mackenzie, evil is a word we use to describe the absence of Good, just as we use the word darkness to describe the absence of Light or death to describe the absence of Life. Both evil and darkness can only be understood in relation to Light and Good; they do not have any actual existence" (p. 136). Is the author of *The Shack* saying there is no such thing as evil? Not at all. But his language isn't very helpful.

What Young is explaining to us is an ancient Christian idea first proposed by early church fathers. They called evil the "privation of the good," which means, according to Young, that evil does not exist. But that's not what Gregory of Nyssa, Augustine of Hippo or any other Christian philosopher or theologian say about it. Who can read the daily newspapers and not believe evil exists?

A simple illustration might help clarify how evil is a privation. When I was a child, my family was touring Wind Cave in the Black Hills of South Dakota. The guide had everyone sit on rock ledges in a large room in the cave. Then he turned out the lights. It was pitch black. I couldn't see my hand in front of my face. It was like being totally blind. And that darkness felt real—because it was real. But it was real as the absence of light. My experience in the cave has stayed vivid in my memory all these years because, for some reason, the guide couldn't get the lights back on and had to leave us behind to get the lights fixed. We had to sit there in absolute darkness—the absence of

light—for about thirty minutes. Believe me, I know darkness exists!

So, yes, darkness is real. So is evil. Both are real precisely as conditions of absence, emptiness, void. Evil is nothing but the absence of good, but it actually exists. God, though, did not create it. Creatures did. Well, to be precise, nobody *created* it because it isn't created at all. We brought it about by falling away from God's perfect will. We are all caught in this condition of absence of the good, which we call "evil."

Evil as the privation of good does not sit well with some people. It didn't with Mack—at least at first. That's understandable. Missy was kidnapped and murdered. That's evil! How can God or anyone say it is only the absence of the good? But we shouldn't use the word *only*. When I sat in that dark cave as a child, I wasn't thinking, *It's only the absence of light*. An absence can be and often is oppressive, filled with terror and even terminal.

Evil is a powerful force, a black hole sucking things and people into itself even though it has no being. And evil is our doing, not God's. The author of *The Shack* is spot on in this regard.

I wonder what happened, however, to Satan and spiritual "principalities and powers" in this story of evil and redemption? Though I don't like to dwell on this dimension of evil, the Bible is full of it! A book like this, it seems, would try to fit Satan and demons into its story somewhere—just because the Bible does. To be sure, the demonic realm is not the cause of evil; *we* are. But that dark personal force in the universe has a lot to do with evil in tempting and luring and giving occasion for it among us. The Bible says that Satan is like a "roaring lion, seeking some one to devour" (1 Peter 5:8). Shouldn't *The Shack* say something about Satan's role in events like Missy's murder?

DECLARATION OF INDEPENDENCE

Evil then is the powerful void created by human defection from God's will. Another associated word is *sin*. *The Shack* doesn't use this word very much, which may cause some people to think Young is soft on sin. However, a careful reading reveals he is almost obsessed with sin. Sin is what brings about evil, and it's a horrible reality that lies at the root of all the chaos and anarchy and lawlessness of our world.

According to *The Shack*, sin is humanity's declaration of independence from God. God frequently chides Mack, and by extension everyone else, for his independence. Only creatures can sin, and they do it whenever, and for whatever reason, they turn away from God and turn in on themselves. Humans fall into self-idolatry. We worship ourselves rather than God. Most of us don't think we are worshiping ourselves, but we do whenever we decide to be the judges of right and wrong in God's place.

When Mack asks Sarayu how the world can be fixed, she says that humans must surrender their right to judge good and evil on their own terms. They must stop declaring independence from God, because that just plunges them into darkness. The result is death because they have separated themselves from the source of life, which is God (p. 136). According to *The Shack*, the world has fallen from the goodness it originally possessed because of humans' free and voluntary choice to try to live without God. We now value all things based on our own interests rather than God's goodness. The author traces this human condition back to the Edenic Fall: "The choice to eat of that tree [of the knowledge of good and evil] tore the universe apart divorcing the spiritual from the physical. They [Adam and Eve and their descendents] died,

expelling in the breath of their choice the very breath of God" (p. 135).

Evil is the result of sin, and sin is the result of human defection from God—the Fall. The picture of the human condition painted in *The Shack* is pretty dismal. But orthodox, biblical Christianity of all stripes has always taught these things. Sin and evil are humans' fault, not God's. They are real in our world because of our misuse of the good gift of free will. The problem is not that a bad substance or force gets into us; it's the old human habit of trying to live independent of God. It's a universal habit and there's no rational accounting for it. The Bible calls it the "mystery of iniquity" (2 Thessalonians 2:7 KJV).

Our relationship with God is broken by our sin. *The Shack* emphasizes that we do not have a right relationship with God, which messes up everything about us. But God wants to restore us. He wants us to be whole. God wants our relationship with him to be healed (which means literally "made whole"), and he's willing to do all the work for us. That's salvation, which means "wholeness."

While I agree with *The Shack's* portrayal of sin as a broken relationship with God, which gives rise to all other sins, I wonder if the book offers a sufficiently profound picture of our human predicament in sin? According to Ephesians 2:1-2, we were all "dead through the trespasses and sins, . . . following the prince of the power of the air," which is Satan. The Bible's picture of our humanity apart from God is bleak to say the least! *The Shack* doesn't deny this, but neither does it really do it justice. And that's because it implies that we are still capable of initiating and establishing a right relationship with God by freely responding to his love without any supernatural, transforming action on God's part within us.

RESTORING BROKEN RELATIONSHIPS

The work of salvation begins with God himself. According to *The Shack*, and historic Christian teaching, fallen people cannot help themselves; they can't pull themselves up by their own bootstraps. The first thing that must happen is the restoration of the broken relationship from God's side. The author of *The Shack* makes absolutely clear that sin has not only damaged us; it has also damaged God. That is, God could not simply forgive humans without doing something about their guilt. The solution is Jesus and especially his cross. God tells Mack, who asked what Jesus accomplished on the cross, that through Jesus' death and resurrection God is fully reconciled with the world (p. 192). In Christ's death on the cross, God was reconciling the world to himself and himself to the world. No theory about how this works is given; it is simply stated as fact.

God had a problem because of sin. He wanted to restore the broken relationship because he loves the world—all people. But he couldn't just wave a magic wand and say "Sin doesn't matter; you're all forgiven," without a price being paid or a penalty being suffered. In Jesus, God did just that, and now God is reconciled fully to the world. As far as God is concerned, the broken relationship is already restored. All that waits is for us to do something.

About God's reconciliation with the world Mack asks, "The whole world? You mean those who believe in you, right?" God responds, "The whole world, Mack." Reconciliation, God explains, is a two way street. God has done his part "totally, completely, finally." God tells Mack that love cannot force a relationship; love can only open the way to a relationship (p. 192). What does the author mean?

I propose *The Shack* is saying that because of the cross every human person's default position is forgiven and reconciled to God. No-

body is excluded. But it's like an amnesty; for it to actually benefit a person, that person has to receive it and not resist it. So that's the rest of the story. God has paved the way to a restored relationship; the rest is up to us. *The Shack* makes crystal clear that forgiveness does not establish a relationship (p. 225). Relationship requires a response from the one forgiven.

The Shack's account of salvation is heartwarming but not quite biblically sufficient. What's missing? The old biblical and Christian truth of *regeneration*, which means being born again, made alive, created anew by the Spirit of God. "If any one is in Christ, he is a new creation; the old has passed away, behold the new has come" (2 Corinthians 5:17). This work of God in us overcomes the spiritual deadness we inherited from our parents and ancestors. Young tries to wrap up all of salvation in the concept of a restored relationship, and there's nothing wrong with putting that at the center. But it can't be the whole story. The only reason we can have a restored relationship with our heavenly Father is because of the action of the Holy Spirit within us. Apart from the Spirit's work, we wouldn't even want a restored relationship with the Father! And it takes more than long conversations with God; it takes a powerful intervention inside us by the Spirit of God re-creating us so that we can be restored to fellowship with God.

A FREE AND VOLUNTARY RESPONSE

Even our response to God is produced in us by God. That is clearly not the point of view of *The Shack*. Throughout the book Young alludes repeatedly to our voluntary response. It's truly up to us. What must we do? *The Shack* describes the required response in several ways, but they all have in common that they are *free* and *voluntary*.

They are truly *our* responses and not God's produced in us.

It's necessary to stop here and explain some theology. Some Christians believe that God is the all-determining reality. In some hidden and mysterious way, God is the ultimate cause of everything. The author of *The Shack* does not believe God determines all things, even secretly or indirectly. Nothing could be clearer. God especially does not manipulate or "bend" people's wills to respond to him as some Christians believe. Whether they respond to God is completely up to them. Yes, because they are fallen, people's wills are bound to sin. But by his grace God grants them the ability to decide freely whether to respond to God or not.

Both of these traditional Christian views fall within the scope of biblical, orthodox Christianity. Both positions can appeal to Scripture and find strong advocates among the church fathers and Reformers. Both strongly affirm that God's grace is the only ground and source of any positive response to God.

There is, though, one thing about *The Shack*'s account of salvation, the restored relationship between God and humans, that does not quite live up to classical Christian theology. It seems to overemphasize human free will to the detriment of God's grace. Scripture and classical Christian theology say that if a person responds rightly to God, that response is enabled by God's grace, which in theology is called prevenient (preceding) grace. God's grace initiates the relationship and makes the necessary human response possible without coercing it. It heals the deadly wound of sin that binds our wills to rebellion against God and frees the will. That way, when we respond to God so that our relationship is restored, we can't boast. Salvation is from beginning to end a gift (Ephesians 2:8-9).

It seems *The Shack* neglects prevenient grace and at least implies that

fallen human beings can, without any special help from God, respond rightly to God's invitation to enter a restored relationship with him. Although many Christians don't realize it, all Christian denominations have rejected this idea. Popular Christian songs, sayings and television shows often convey a different idea, which portrays God as waiting for us to take the initiative. If Young does not agree with this unorthodox position, he should have done more to underscore God's grace prior to our response. As it is, the author leaves the impression that we are capable of responding by ourselves. That's wrong in light of Philippians 2:12-13: "Work out your own salvation with fear and trembling; for God is at work in you, both to will and to work for his good pleasure."

THE CORRECT RESPONSE

What is *The Shack*'s idea of our proper and necessary response to God's work in Christ? First, it is to return to God, to turn away from our independence. God tells Mack the way to salvation is "By *returning*. By turning back to me. By giving up your ways of power and manipulation and just come back to me" (p. 147). This turning back is called *conversion* in traditional Christian jargon.

Second, the way to a restored relationship with God is by trusting him, not by obeying rules. God clearly shows Mack that keeping rules is not the way back to a right relationship. God shocks Mack by telling him, "In Jesus you are not under any law. All things are lawful" (p. 203). The law, God says, was to show us our inability to be righteous by our own works (p. 202). Martin Luther said this long ago, and it sparked the sixteenth-century Reformation. But Luther himself would say he simply got it from the apostle Paul (Galatians 3:19-29). So Young is not saying anything new or heretical here. But if rule-keeping isn't the way to a right relationship with God, what is?

In one of the simplest and most profound statements in the book, God tells Mack that he wants people to trust him with the little ability they have, and grow in loving others as God has loved him (p. 181). A major theme of *The Shack* is *trust*. God wants our trust, and that will lead to everything else. Theologians call this "justification by faith alone."

God goes a little further in addressing the change he wants in Mack (and in us) so that they can have a restored relationship. At one point God encourages Mack to turn away from independence by ceasing to be God's judge. He equates the faulty human declaration of independence with judging God. When people do that they push God away from themselves by implying that they know better than God how things should be (p. 165). So that's what trusting God means—not judging God but believing he is good no matter what happens. We must become like a little child toward good parents; we might not understand their ways but just believe they are unqualifiedly good.

The last step in the restoration project is the most difficult for Mack and most of us: forgiving others who have terribly wronged us. In one scene in the book, a vision of heaven, Mack sees his own abusive father and runs to embrace him. It seems a little too easy and sweet. But afterward Mack is relieved of a great burden. The next day God says, "Forgiving your dad yesterday was a significant part of your being able to know me as Father today" (p. 221). Then comes the hardest part of all. God asks Mack to forgive the monster who kidnapped and murdered his daughter. Forgiving him is for Mack's as well as the murderer's good: "Mack, for you to forgive this man is for you to release him to me and allow me to redeem him" (p. 224). Eventually, Mack forgives the Little Ladykiller, once he realizes it does not require forgetting what the man did or even having a rela-

tionship with him. God tells Mack that forgiving does not mean excusing. Furthermore, forgiving does not mean abandoning justice. God tells Mack that he has no duty to justice that forbids him from forgiving Ladykiller. God will handle the justice side of things (p. 226). In other words, vengeance, if there is to be any, is God's. Leaving that to God is part of trusting him.

Evil, sin and *salvation.* This is what *The Shack* is all about. Is it good, biblical theology? Is it true? Should readers believe its message? Some critics will no doubt urge you not to believe it. To some, the message of the book is that God is an easygoing grandfatherly figure who indulges us and doesn't hold us accountable for what we do. To others, the message is that God wants to swallow us up in himself and leave no room for independent thinking or action. There's some truth in both criticisms of *The Shack*, but overall the book's message about evil, sin and salvation is biblically and theologically sound.

8

Will Child Abusers
Be in Heaven?

I MUST CONFESS THAT I WATCH TOO MANY crime documen-
taries and docudramas on television. I'm fascinated by the widely
diverse reactions of murder victims' families to the perpetrators.
One pattern I've noticed is that victims' families almost always be-
lieve the accused person is guilty, even when there is very little evi-
dence and the person is exonerated by a jury. I remember one docu-
mentary that told the story of a teenage boy accused of killing a
neighbor girl. The girl's parents spewed venomous hatred for him
and wished him every possible pain. Years later, after he served some
time in prison, the boy was proved not guilty. DNA evidence revealed
that someone else committed the crime. Interestingly, the girl's par-
ents declined to comment.

More fascinating, however, are two radically different responses
of murder victims' families when the accused is found guilty. Some,
perhaps the majority, wish the murderer would suffer death; some

even volunteer to "push the plunger" that releases the lethal dose of poison in the death chamber. Surely the "Great Sadness" has taken over their lives and caused them to hate. Who can blame them? What would any of us feel if our child were murdered? I can't say what I would feel or do. But I pray for these bitter, angry and even hate-filled parents of murdered children.

Occasionally I see a different reaction. Once in a while a mother or father says something like "I have already forgiven him for killing my child." It's stunningly rare and brings up feelings of confusion and wonder. How could a parent forgive the monster that murdered his or her child? But it happens. On October 2, 2006, a crazed gunman invaded an Amish schoolhouse in Pennsylvania and shot ten girls before killing himself. Five of the girls died and five survived. Soon after the tragedy, the Amish community gathered and forgave the murderer. The media went wild. How could they do that? Talk shows explored the question and found few answers. Clearly, however, the Amish community's Christian faith had everything to do with it.

I wonder what would have happened if the murderer had survived? Would the Amish community still have forgiven him? I can only guess that they would. Would they have cooperated in his trial by testifying against him? It's hard to say. But most people considered their forgiveness of the dead gunman a miracle.

In 1956 five American missionaries flew into a South American jungle to try to reach the Waorani (Auca) Indians with the gospel. Among them were Nate Saint and Jim Elliot. All five were killed by the Indians. Books and films have been made about the event and especially about its aftermath. Instead of calling in the troops to capture and perhaps kill the Indians, Rachel Saint and Elisabeth Elliot,

wives of Nate and Jim, forgave their husbands' murderers and even went back to make friends with them. Eventually the very men who killed the five were converted to Christ through the ministries of Nate's and Jim's wives and grown children.

A CHALLENGING ACT

What are we to make of forgiveness such as that? Much of *The Shack* is about it; forgiveness lies at the very heart of the story. And it's not easy forgiveness. After all, Mack's little girl was kidnapped, raped and murdered by the monstrous Ladykiller. To say the least, Mack struggled with his feelings toward the murderer and toward God. He also struggled with feelings toward himself for allegedly allowing it to happen. His daughter was kidnapped while he was busy doing something else. The Great Sadness that consumed Mack included a lack of forgiveness. But it wasn't only lack of forgiveness toward the murderer. Mack's encounter with God revealed that most of his spiritual problems stemmed from his lack of forgiveness toward his own abusive father.

Forgiveness is one of life's most challenging acts—especially when it comes to abusers of children.

Are we to believe that God forgives abusers and murderers of children, and allows them into heaven? Do we even want to be in a heaven populated by such people? These are primary spiritual questions that strike a primitive chord within us. In our society there's no lower being than a child abuser. Even prison inmates hate those who abuse children. A priest who was convicted of sexually abusing numerous boys was murdered shortly after entering prison; nobody doubts the reason.

Most of us wouldn't lay a hand on a child abuser, but neither do we

grieve if one is beaten up or killed. We consider them less than human and therefore fair game for whatever happens to them. So how can we even think of seeing them in heaven? What would our reaction be if we saw one there?

The Shack raises serious questions about our spiritual condition when we hate anyone—even abusers.

That's where the book hit me the hardest. I suspect many of us have someone in our past, or perhaps present, whom we loathe, even if we say we don't hate anyone. We might even tell others, "Oh, I've forgiven him." But deep within the recesses of our heart we harbor bitterness, resentment and hate for that person. It's human. But it's not good or right. *The Shack* makes us face that within ourselves, which is one of its strongest virtues. It makes us uncomfortable. Even if we're not like most others and really don't hate anyone, in *The Shack* we are faced with the question of what our attitude would be toward a child molester and murderer. Would we want that person to be redeemed by God and welcomed into heaven?

MAKING IT PERSONAL

I don't think of my own life story as unique at all. Only the details are different than many others'. My father was not physically abusive, but he was a master of emotional and spiritual abuse. He lived two lives. Those who only knew him as their beloved pastor refused to see the hints of that other life I lived with every day. After he went to prison, they didn't want to hear that they had been fooled by him or that I had suffered years of emotional and mental abuse from him.

I was unfortunate enough to have his secret life come crashing down into mine when I was twenty-five years old. While attending seminary, I was his assistant pastor. Like many others, I saw things

in his life and ministry that I should have questioned. But he was high on a pedestal, and it seemed unthinkable to question this man of God. One October night he called me from a distant city where he had supposedly gone to attend a convention of ministers. He was in jail. I spent all night on the phone getting him out of jail, and then I conspired with him to cover it up. Then he asked me to resign as his assistant pastor because of what I knew about him. I was devastated, and a seed of bitterness was planted deep in my heart. I didn't resign until I finished seminary, and my father despised me for what I knew. Years later when I tried to intervene in his life, he rejected and verbally abused me.

As I reread the previous paragraph, it seems only the tip of an iceberg of my dysfunctional relationship with my father. The whole story is long and sordid and depressing. But my situation is not unique. I have discovered that many ordinary people have someone who has wounded them so deeply they simply cannot find it within themselves to look forward to meeting him or her in heaven. Do I look forward to meeting my father in heaven? I've struggled with that for years. He died unreconciled to me. To be perfectly honest, his death was a great relief to me.

Needless to say, I identify with Mack. Of course, what my father did to me is nothing like what the Ladykiller did to Mack, his daughter and their family. I'm not making that comparison. But throughout the book I identified with Mack's deep wounds caused by his father and then by the Ladykiller.

GOD FORGIVES EVERYONE

Not very long after reading *The Shack* I was sharing its story with a friend. I expressed reservations about its picture of heaven and about

the wideness of God's mercy in the book. My friend, who is an influential pastor and theologian, said, "I envision a heaven in which I will see a little girl who died in the gas chamber of Auschwitz hugging Hitler and forgiving him." That almost made me gag. But that's the picture of heaven in *The Shack*. According to it, not only might I see my abusive father there; I may also witness a loving and joyous dance around God's throne including the worst monsters of world history and their victims.

What in *The Shack* leads me to that conclusion? First, God says things to Mack like, "In Jesus, I have forgiven all humans for their sins against me" (p. 225). God reminds Mack that while Jesus was on the cross he asked his Father to forgive the very men who were murdering him. "When Jesus forgave those who nailed him to the cross they were no longer in his debt, nor mine. In my relationship with those men, I will never bring up what they did, or shame them, or embarrass them" (p. 225).

I wonder how many people have ever contemplated Jesus' words from the cross about the soldiers (and perhaps others who indirectly participated in his execution)? He said, "Father, forgive them; for they know not what they do" (Luke 23:34). What greater crime could there be than cruelly torturing and slowly killing an innocent and righteous man? Especially when that man is also God's own Son? Do you think the Father refused to forgive them? Surely Jesus was expressing the very heart of God, and his Father responded by forgiving them. Notice that not one of them is said to have repented! They were busy dividing up his clothes!

Is the author of *The Shack* implying that God simply forgives people regardless of the condition of their hearts? He most certainly is. Nothing could be clearer. I'm not at all sure he's right about this, but

I am sure, based on the biblical witness, that God *wants to forgive* everyone, no exceptions. But perhaps complete forgiveness requires some response from the one needing it. Exactly when forgiveness happens is a matter of theological speculation and argument. But practically it makes little difference. The point is that God's heart is nothing but love toward all people. And ours should be too.

Understandably, Mack spews venom and hatred toward the Little Ladykiller. Who wouldn't? God lovingly nudges him toward forgiveness. First, God appeals to Mack's self-interest. When someone wants fallen humans to do something, they must above all appeal to our self-interest! God tells Mack to forgive the Ladykiller for Mack's sake. Forgiveness releases people from something that is eating them alive by destroying their joy and capacity for absolute love (p. 225). Second, God appeals to Mack's sympathy. He explains to Mack why people become child murderers. He urges Mack to love and forgive the man "not for what he's become, but for the broken child that has been twisted by his pain" (p. 225).

It's possible to interpret that last sentence as being about the Ladykiller's victim. But the context implies that the Ladykiller acted out of the pain resulting from his own childhood. Not very long ago I watched a crime documentary in which an interviewer questioned a child murder about the reasons for his acts. Without in any way shrugging off his own guilt, the murderer said he committed the crimes out of self-hatred. They were the worst acts he could think of, and he did them because he hated himself. The twisted reasoning made no sense, but I can only assume the man suffered terribly as a child and youth. Someone caused him to hate himself. According to *The Shack*, then, when we think about a child abuser or murderer we should contemplate the forces that twisted that person into a monster.

Mack is reluctant to let go of his hatred because he supposes that would imply forgetting about what happened to his daughter. God assures him that's not the case. Forgiveness does not require forgetfulness. Rather, it is about "letting go of another person's throat" (p. 224). Then Mack acknowledges that he can't do this himself, and God promises to help him to acquire a nature that finds more power in love than hate (p. 225).

I wish Young had spent more time on that point. "To err is human; to forgive is divine." Indeed. I don't think I can forgive my father without supernatural help from God. And *help* isn't a strong enough word for what I need. I wish the author had spoken more powerfully and directly about the power of God to change our hearts. The Bible speaks that way. Ezekiel 36:26 says, "A new heart I will give you, and a new spirit I will put within you; and I will take out of your flesh the heart of stone and give you a heart of flesh." Sure, the God of *The Shack* assures Mack of his help, but I think it takes more than God's "help." That kind of forgiving is not within human power; it has to be a supernatural gift.

I once witnessed that marvelous gift given to a person. When I was an assistant pastor, a man joined our church who hated African Americans. He was an out-and-out racist. We didn't know that when he joined, but our church was filled with sinners, so it wouldn't have made any difference. One evening during a prayer meeting, someone knelt with Ken and prayed for him. Ken sobbed and cried; clearly God was doing a work in him. Later that same evening Ken knelt and prayed with a black man, confessing his sin of race hatred and testifying to his deliverance. I saw the change in Ken's heart. From that night on he went out of his way to love and help people different from himself.

I think that kind of supernatural help is what Mack would need to forgive his daughter's murderer. I need it to forgive my father. (Why do I keep expressing that in the present tense? All I can say is that it's a process.)

Last, God appeals to Mack's sense of justice. Mack fears that forgiving the Ladykiller will betray his daughter. He asks God if it is fair to Missy not to stay angry with her killer. God assures him that forgiveness does not excuse anything. Besides, it's okay to remain angry even after forgiving the man (p. 227). I have to question this assertion. If it's okay to remain angry at someone after forgiving them, does God remain angry at us after forgiving us? It doesn't seem so in either the Bible or *The Shack*. It seems to me that real forgiveness means giving up anger. It doesn't require forgetting the evil deed or trusting the perpetrator, to be sure, but it must mean letting go of anger. That's what makes it so difficult if not impossible apart from supernatural help!

Mack experiences two powerful events of forgiving in *The Shack*, and they clearly lead to the lifting of his Great Sadness. First, he forgives his father in a very dramatic encounter in heaven. Sarayu takes him there, and he meets and forgives his father: "They exchanged sobbing words of confession and forgiveness, as a love greater than either one healed them" (p. 215). All that's sweet and light and beautiful. But maybe a little too much. During the encounter Mack says to his father, "Daddy, I'm so sorry! Daddy, I love you!" (p. 215). The whole scene kind of repulsed me. What did Mack have to apologize to his father for? There's no hint in the book that Mack did anything wrong to his father. Maybe for not forgiving him sooner? I would have liked to see more expression of regret and even repentance toward Mack by his father. It's not there. Maybe my own life experi-

ence got in the way of fully appreciating that scene. My guess, though, is that many men felt as I did when they read it.

Mack's act of forgiving the Ladykiller is not recounted in *The Shack*, but it is assumed. On the book's very last page the narrator reports that even as he writes the book's ending, Mack is testifying at the murderer's trial and hopes to meet with him after the verdict is rendered (p. 248). That leaves things a little vague, but we have to assume Mack genuinely forgave his daughter's murderer while still seeking justice for his daughter.

WHO IS FORGIVEN?

So what does *The Shack* say about whether child abusers will be in heaven? We can only conclude that it says they will be there. All of them? Not necessarily. God tells Mack that forgiveness does not by itself establish relationship. A restored relationship is only possible when the person being forgiven speaks the truth about his or her wrong actions and changes direction. Only then can trust be restored, which is necessary for relationships. God tells Mack that forgiveness releases them from judgment but does not automatically restore relationship. For that, change is necessary (p. 225).

Once again, I have to register some hesitation about *The Shack*'s theology. If forgiveness releases a person from judgment, and God has already forgiven everyone on the cross, then that would seem to render judgment impossible. And yet the Bible says unrepentant sinners will be judged. There's something amiss in *The Shack*'s version of forgiveness in spite of its powerful message.

So what's the verdict about child abusers and other monsters? One reading of *The Shack* would conclude that *everyone* goes to heaven. That's called universalism, which some of the church fathers believed

and taught. But it has generally been considered a heresy among orthodox Christians of all denominations. If forgiveness releases someone from judgment, and God forgives everyone because of what Christ has done, then everyone must go to heaven! *The Shack* doesn't tell us anything else.

Another reading of the book leads to the conclusion that getting into heaven requires more than forgiveness. It requires a right relationship with God. And in *The Shack* a right relationship with God requires confession of sin and trust in him. But can we really picture forgiven people going to hell? Something seems not quite right about *The Shack*'s theology at this point.

I return to a basic problem I have with *The Shack*. In the book, God has already forgiven everyone of everything, and he absolves everyone of guilt and shame. He isn't even disappointed in us! Angry? Yes. Disappointed or condemning? No. So it would seem that everyone has a ticket into heaven just because Christ died for them. But it's hard to think the author of *The Shack* wants us to believe everyone will be in heaven. If he does, he doesn't explicitly say so and he would be biblically and theologically wrong. I choose to think he's more biblically and theologically correct than that.

Where does the Bible clearly say that not everybody will be in heaven? Luke 16:19-31 tells the story of poor Lazarus and the rich man who ignored him. Upon death, the rich man goes to Hades (an ancient term for hell) and suffers torment. If that's not enough, consider Matthew 25:41, where Jesus says he will say to some, "Depart from me, you cursed, into the eternal fire prepared for the devil and his angels."

The biblical and orthodox Christian solution is that the cross of Jesus offers every person a ticket into heaven, which is an offer of free

forgiveness, but not everyone uses the ticket. They spurn God's offer of forgiveness and mercy, tearing up and throwing the ticket away. Hell, then, is possibly the "painful refuge" God provides for those who don't want to worship him forever in his heaven. Building on the idea of evil as absence of the good, in *The Great Divorce* C. S. Lewis depicts hell as a shadowy, relatively unreal existence. And people who go there prefer it to heaven because they have diminished their own reality by persisting in sin. They "fit" in hell rather than in heaven, and when given the chance to be in heaven, they decline.

I wish William Young had said more about hell. It's not necessarily a place of literal fire and physical torment. But it is a biblical place. It's hard to escape its reality when we read the words of Jesus, who spoke more about hell than anyone in Scripture!

So who goes to hell? *The Shack* is right that it won't be rule breakers just because they broke God's rules. Instead hell is for those who refuse to trust God and receive his forgiveness, and who refuse to forgive others. It's for those who revel in their hatred and bitterness toward God and fellow human beings.

MONSTERS IN HEAVEN

So what about child abusers like the Ladykiller? Will they be in heaven? It's impossible to say. Only God and the abuser can decide that. Does the abuser repent and accept God's mercy or stubbornly resist God and persist in evil ways? The Bible is quite clear that anyone who repents and trusts in God will inherit heaven, no matter what they have done. Remember the thief on the cross beside Jesus (Luke 23:39-43)? By all accounts he was a vile person, and yet Jesus forgave him and promised him paradise because he asked Jesus to remember him when he came into his kingdom. On the cross Jesus

was being pretty generous with his mercy! What indication is there that he has changed?

As difficult as it may be, we must conclude that, most likely, there will be child abusers in heaven—assuming they repent and throw themselves on God's mercy. Is that even possible for a child abuser? With God all things are possible (Matthew 19:26). Even if he has not already forgiven such people, which I doubt in spite of *The Shack*, he loves them and wants a restored relationship with them. Presumably he is doing everything possible, short of coercion, to draw them to himself so that he can forgive them and establish a relationship of love with them.

The question for us is, Do we really want child abusers like the fictional Ladykiller to be in heaven? Do we want those who have mistreated us to be in heaven? How about Hitler? There's where we get stuck spiritually. We might have everything else quite right theologically and spiritually, but not have God's heart for the dregs of humanity. And what are we? According to Romans 1—3 *we* are the dregs of humanity! Read it and weep.

As difficult as it is emotionally, theologically I have to believe my father may very well be in heaven. And I have to ask God to help me overcome any reluctance at that thought. After all, I deserve it no more than he. It's all by God's grace.

9

Isn't Jesus a Christian?

MANY YEARS AGO I TAUGHT AN ADULT Sunday school class that included some new Christians. I don't recall the subject that Sunday, but I almost laughed when a middle-aged man in the class asked, "When did Jesus become a Christian?"

It sounds like a funny question. But it comes up in *The Shack* in a very serious way—as part of a larger question about people of other religions. Mack is conversing with Jesus about what it means to be his follower, and Jesus informs him that it's not what many people think. Mack says, "I have been told so many lies" (p. 181). In context, his declaration means that what Jesus is telling him has little or nothing to do with what he had been taught in seminary and church.

LIVING WITHOUT AN AGENDA

Clearly, Mack is disillusioned with establishment Christianity. He's not alone; I meet people every week who are fed up with their churches because of a seeming lack of authenticity and failure to avoid cultural accommodation.

Jesus answers Mack's exclamation with, "Mack, the world system is what it is. Institutions, systems, ideologies, and all the vain, futile efforts of humanity that go with them are everywhere, and interaction with all of it is unavoidable" (p. 181). Speaking of the world system, Mack replies, "But so many people I care about seem to be both in it and of it!" Then the narrator gives us a little insight into what Mack is upset about. Mack's friends and family are "sold out to religious activity and patriotism" (p. 181). Could the author be thinking of the so-called Religious Right in America?

Jesus reveals to Mack that being his follower means living and loving "without any agenda" (p. 181). In other words, Jesus apparently is repudiating all those political and religious platforms and activities that people tie together with being his follower, and they offer their love only to those who agree with them.

Mack responds, "Is that what it means to be a Christian?" Jesus' reply may astonish some readers: "Who said anything about being a Christian? I'm not a Christian" (p. 182). Sometimes we elevate our religious affiliation to the status of an idol. Are we more interested in being "good Christians" than being radical disciples of Jesus? It seems that's what author William Young is getting at. Being a Christian, for him, is not automatically a good thing.

Jesus' declaration that he's not a Christian won't surprise some people because they know that Christianity is the religion developed by Jesus' followers after his death and resurrection. It didn't exist before that. Then the question becomes, Did Jesus become a Christian after it was formed? Can we imagine Jesus holding membership in any movement or organization? And if *Christian* literally means "Christ follower," how could he be one? Then he'd be his own follower. So the idea of Jesus being a Christian is kind of absurd.

JESUS WILL TRAVEL ANY ROAD

But that's not the real shocker, which follows immediately after Jesus' denial that he's a Christian:

> Those who love me come from every system that exists. They were Buddhists or Mormons, Baptists or Muslims, Democrats, Republicans and many who don't vote or are not part of any Sunday morning or religious institutions. I have followers who were murderers and many who were self-righteous. Some are bankers and bookies, Americans and Iraqis, Jews and Palestinians. I have no desire to make them Christian, but I do want to join them in their transformation into sons and daughters of my Papa, into my brothers and sisters, into my Beloved. (p. 182)

If you're like me, you sat up and took notice when you read this! It's a pretty radical statement to put into Jesus' mouth. Jesus doesn't want to make people Christians? That goes against the grain of everything most Christians in America and perhaps throughout the world are taught. So what is *The Shack* saying? Mack asks the question most of us would ask if we heard Jesus say something like this. Is Jesus saying that all roads lead to God (p. 182)? Many liberal religious people believe that. It's a kind of lazy relativism that overlooks the radical differences between many of the religious roads people walk. To see its absurdity think of Satanism leading to Jesus! How could that be?

The great thing about this exchange between Jesus and Mack is that most of us have asked these questions. The author of *The Shack* is very adept at putting reasonable words in Jesus' mouth. The question remains, of course, whether they are biblically and theologically correct. Many critics have already condemned these ideas as relativistic and theologically liberal.

To Mack's question Jesus responds negatively and positively. He tells Mack that most religious "roads" lead nowhere, but he—Jesus—will travel any road to find us (p. 182).

That two-page exchange between Jesus and Mack is probably the most profound and troubling in the entire book. I wonder how many folks who say they really love *The Shack* even stopped to think about what they read there? There's an amazing phenomenon known to every teacher who assigns reading homework and then asks students to discuss it. People tend not to see what they don't expect to see in a book or article. When something sticks out as too strange, readers often overlook it and don't even remember it when asked about it.

That's a common way of reading the Bible. After twenty-six years of teaching Bible and theology to college, university and seminary students, I've concluded that many Christians simply miss much of what's in the Bible because they don't know how to handle it, and it's not what they were told to expect there. How many Bible readers know, for example, that the Bible says a great deal about wealth and poverty, and warns against accumulating money?

Jesus and Mack's exchange about Christianity, Jesus' followers and religious paths is truly astounding. But it's so brief it's difficult to interpret. What exactly is Young trying to tell us? Is this some kind of universalism—the belief that all people will eventually be saved? Is it an expression of relativism—the belief that there are no absolutes? Is it an expression of inclusivism—the idea that people who never hear the gospel preached will somehow be given an opportunity to believe in Jesus? Is the author siding with theologians who speak of "anonymous Christians"—people who are truly loving even though they never accept Christ formally?

NOT BIG ON RELIGION

As we try to interpret this passage of *The Shack* we must keep in mind a pervasive theme of the book: a distinct aversion to institutions and systems, which more often hinder rather than help authentic Christian faith. When Mack asked Jesus about his attitude toward religious institutions, Jesus replied, "I don't create institutions—never have, never will" (p. 179). Okay, that doesn't seem too radical. There's no record that Jesus founded any organizations or institutions. But in context it sounds like he doesn't even approve of them! Then comes the other shocker. Jesus tells Mack, "So, no, I'm not too big on religion" (p. 179). Not too big on religion? What can Jesus mean? Didn't he start a religion?

The Shack's sentiments about religion, systems and institutions is ambiguous. That is, it's hard to interpret. The author tosses these saying of Jesus out like little grenades and leaves us to figure out what to do with them. Some might consider that irresponsible. But perhaps his main concern is not so much to convince us of something as to make us think in new and fresh ways. Let's explore what he might mean.

First, *The Shack* is trying to change our minds about what it means to be a follower of Jesus and friend of God. Most of us believe these things necessarily involve a very high level of loyalty to and involvement in religious organizations. We grow up thinking the Christian *religion* is our primary identity. *The Shack* is trying to separate loyalty to Jesus and love of our neighbors, on the one hand, from loyalty to human organizations and systems on the other hand. And it's going further than that. It implies that religious organizations and institutions can often hinder our being faithful Jesus followers.

Why do we often put loyalty to religious organizations and insti-

tutions before Jesus? *The Shack* says it's because we crave certainty and security, which we think institutions and systems, like rules, can provide. The God of *The Shack* wants us to give up our rage for certainty and security, and in faith throw ourselves on him in utter trust. (*The Shack* even has God saying to Mack, "I have a great fondness for uncertainty" [p. 203]. Now that's enigmatic!) Does this mean all institutions, organizations and systems are bad? Not necessarily. But according to *The Shack* they easily become substitutes for God insofar as we trust in them rather than in God. God tells Mack that human systems cannot provide security (p. 179). Only God can do that, and it's a matter of radical trust rather than proof or safety or stability. Systems and institutions may provide some measure of these, but they cannot replace the security we find only in trusting God and having a relationship with him.

So, according to *The Shack*, Christians tend to think wrongly about being a Jesus follower. We identify following Jesus with religious activity in and through human institutions that embrace some humanly created system of doctrine and morality. Some even identify it with loyalty to some political party or ideology. That's all wrong. We can be involved in institutions that work on behalf of God in the world, and we can believe in doctrines, but we have to be wary of them and hold them loosely. They too easily become corrupt, dead, irrelevant or abusive. After all, they're human. Even Christianity itself, as an organized religion, is a human invention and therefore subject to failure.

All this reminds me of a classic book by Christian theologian Emil Brunner (1889-1966) titled *The Misunderstanding of the Church*. Brunner argued that the church is not an institution even though it takes on institutional forms. The church must always be distin-

guished from its organizational apparatus and things like flow charts, doctrinal statements, ceremonies and buildings. The true church is fellowship, the fellowship of those who believe in and follow Jesus. Brunner's contemporary Karl Barth (1886-1968) argued that Christianity is not even a religion! It is the gospel. Young takes this one step further: being a follower of Jesus Christ is not about membership in any church or even identifying oneself as Christian. It is solely about trusting God alone, finding our security in him, and loving him and others unconditionally.

Second, *The Shack* is trying to change our minds about people who we normally don't think of as Jesus followers. Jesus isn't a Christian, so why should all of his followers have to be Christians? Our default attitude is that all true Jesus followers are openly Christians by identity and affiliation. But in *The Shack*, Jesus says he has followers who "come from every system that exists," including Buddhists, Mormons, Muslims and even Baptists! Most of us don't have a problem with Baptists being Jesus followers. But Muslims! How can that be?

Notice that the author has Jesus say they "come from every system that exists." And he uses the past tense: "They were Buddhists." Does he mean that some Jesus followers used to be Buddhists but they became Christians when they embraced Jesus? If so, how would that explain the inclusion of Baptists and Republicans and Americans in the list? And how does that square with Jesus saying he has no desire to make them Christians? So I think we can discount the past tense as irrelevant to the point. Surely the author is intending to have Jesus identify some of his followers as adherents of non-Christian religions.

The Shack is saying something more radical than just that Jesus followers *used to be* all kinds of different things. Who doesn't already

know that? Why would he even need to say that to Mack (or us)? Clearly, Young is telling us that he believes being a Jesus follower is not limited to Christians, to say nothing of Americans or Westerners. How can this be?

Apparently, the Jesus of *The Shack* is simply unfolding what the Jesus of the New Testament meant when he told his disciples "And I have other sheep, that are not of this fold" (John 10:16). At that time most Jews thought they were the only sheep of God's fold. Jesus corrected them. Now most Christians think they are the only sheep of God's fold. *The Shack*'s Jesus is correcting them. Being a Jesus follower, then, does not require being a Christian. In fact, according to *The Shack*, sometimes it can be a hindrance. It was for Mack!

NON-CHRISTIAN JESUS FOLLOWERS

Can a person be a Jesus follower without being a Christian? We find an example in the New Testament: Cornelius the Roman centurion. The Bible says he was "a devout man who feared God with all his household, gave alms liberally to the people, and prayed constantly to God" (Acts 10:2). But he was not a Jew, and there's no indication he was attached to any Jewish institution. (Some scholars think he was a "God-fearer," which meant a Gentile who faithfully attended synagogue and observed the Jewish religion but was not circumcised.) A plain reading of Acts 10 indicates very strongly that Cornelius was a Jesus follower even before he met Jesus. That's because he feared God, gave alms liberally and prayed constantly to God. Could this mean that anyone who does these things is a Jesus follower even though he or she has never heard of Jesus?

In Matthew 25 Jesus says that at the final judgment "the King" (God) will welcome into heaven people who don't even know they

are among the "righteous." They are, however, because they fed the hungry and gave drink to the thirsty and clothed strangers (all metaphors for lovingly helping the needy). The context makes clear that these people didn't think they served God, but God knows they did. He accepts their compassion toward the poor and needy as service to him even if they belonged to other religions (which is clearly the implication of the passage).

There's a famous passage in C. S. Lewis's book *The Last Battle*, where Aslan, a lion who is a type of Christ, accepts the worship of Tash, a false God, as worship of himself. The warrior Emeth served Tash, but at the judgment Aslan says no service that is not vile can be done to Tash; it is really done to Aslan. Clearly Lewis was thinking of the Matthew 25 passage. Emeth is saved without ever being a Christian.

Lewis and Young, together with many Catholic and Protestant Christian thinkers, are inclusivists with regard to non-Christians. Without using the term "anonymous Christians," they are saying the same thing: that many people who are not organizationally Christians are Jesus followers because they love him and do his works.

I agree with the author of *The Shack* about this. I know well that critics of this point of view, who prefer a theology known as restrictivism (because it restricts salvation to Christians), can marshal Scripture passages to defend their view. But I find the already-mentioned Bible passages compelling. I am also drawn to inclusivism by the character of God as revealed in Jesus Christ; he is not a stingy God who parcels out salvation only to those who call themselves by a certain religious label or even who say the right words. He is the God who came to die for the whole world (John 3:16-17)

and does not want any to perish (2 Peter 3:9). I cannot imagine him *not* judging people mercifully by the light they have and their responses of love to it.

Finally, we come to the question of relativism. Remember Mack's question to Jesus, "Does that mean that all roads will lead to you?" (p. 182). God's response was that most roads lead nowhere, but he will travel any road to find us. In other words, if non-Christians are saved, as *The Shack* clearly implies, it isn't because some non-Christian religions lead to God but because God graciously condescends to meet people on their own religious journeys if they have hearts open to him.

In other words, according to *The Shack*, "man's search for God" is irrelevant to salvation and to being a true Jesus follower. What's relevant is the direction of a person's heart—led by love into service to others—and God's mercy that leads him to meet such people as they walk a religious path that leads nowhere. People do not become true Jesus followers through observing God's revelation in nature or culture or religion. They only become true Jesus followers by following their hearts toward the true God and the true God meeting them and taking them the rest of the way. Salvation, then, is always supernatural and a work of God's mercy and grace. It cannot be by works independent of God.

Clearly, this is the farthest thing from relativism. *The Shack* is not luring readers into that absurd philosophy. (I call it absurd because it is self-contradictory. To say there are no absolutes is itself an absolute statement!) Jesus is "the way, and the truth, and the life" and the only way to the Father (John 14:6). But that doesn't mean he can only save those who know him by name or that only they can be his followers.

114

KNOWING JESUS IMPLICITLY

When I was a child, I listened with fascination to stories told by my missionary aunts and uncles. One story was about a Muslim woman in Trinidad who rode up to a Christian church in a taxi and jumped out saying to a missionary, "You're the man I saw in the vision." She had become disillusioned with the Muslim religion and began searching for and praying to the true God without knowing anything about him as Father, Son and Holy Spirit. One day, according to her testimony, she saw a vision of a man standing in front of a church. She knew she was being directed to him. She found him, and he led her to a deeper understanding of Jesus, whom she already knew implicitly.

These stories were favorites of my aunts and uncles and other missionaries, who were extremely conservative women and men! But they knew from experience that God can work in a person's life without any missionary reaching them with the gospel.

Someone may object that these stories, like that of Cornelius in Acts 10, tell only of people being directed by God to Christian missionaries. But the question is whether they were already in some sense Jesus followers before they met any missionaries. They were. I assume, with good reason, that there are many such people in the world who never come into contact with any explicit gospel message about Jesus Christ.

The Shack and I are treading on dangerous ground here. Many critics will ask, "Then why send missionaries to the lost?" Well, there are several good responses to that. First, because God said to. Second, because it is better for already-saved people to know who their Savior is than to remain ignorant of him. A third answer may be that's the way God finds them on their road to nowhere.

10

Where Is the Church in Experiencing God?

A FEW YEARS AGO THE CHRISTIAN UNIVERSITY where I teach issued an edict about hiring professors: they must be active members of either a church or synagogue. To many it seemed innocuous enough, but howls of protest arose from certain quarters of the campus and community. The editorial page editor of the local newspaper wrote a column arguing that Abraham Lincoln was a good Christian even though he never joined a church.

I wrote a responding column, which the newspaper published. There I argued that Christian history knows nothing of a churchless Christianity, and certainly the New Testament knows nothing of it either. It's a purely modern phenomenon. And I boldly stated that Abraham Lincoln, though a fine president and good man (by all accounts), was no Christian. He had plenty of opportunity to join any church in Springfield, Illinois, or Washington, D.C., and refused. Being a Christian necessarily includes involvement, if not

membership, in a Christian community.

After my column appeared in the newspaper, a neighbor challenged me about it. She said that she is a good Christian but rarely goes to church. Of course, I didn't want to get into a debate with her, but I simply reaffirmed what I know to be the case as a historical theologian and at least would-be biblical scholar: there is no such thing as authentic Christianity that is purely individualistic. She remained chilly toward me after that.

I am willing to bet that millions of Americans consider themselves good Christians but shun church membership or involvement. I live in a county of about 200,000 citizens that harbors at least 125 Baptist churches. It's the thickest concentration of Baptist churches per capita in the United States and probably the world. But I have met people here who consider themselves Christians, and even Baptists, but have no church affiliation.

In the previous chapter I discussed how, according to *The Shack*, being a Christian isn't what matters—being a Jesus follower is. I have some problems with that distinction, especially as it is drawn in *The Shack*. It's too strong a distinction. But even if I agreed, I would still argue that involvement in Christian community is essential to being a true Jesus follower. There's no hint of individualistic Jesus-following in the New Testament or in Christian history, until the modern era.

One of the problems I have with *The Shack* is its implication that a person can experience God fully and authentically apart from Christian community. I'm not arguing that membership or involvement in an organized church is necessary. I don't think a person has to belong to a denomination or even a local church such as First Church Downtown to be a follower of Jesus. Not at all. The true church is not the institution or organization, but the fellowship of God's people.

What I miss in *The Shack* isn't an emphasis on structured religion or organized church life; I miss any hint that belonging to a community of fellow believers is crucial to the life of faith. The book exhibits a kind of "Jesus and me" mentality that is out of sync with its overall exposition of what it means to follow Jesus and have a relationship with God. It all remains on the individual level.

I'm not suggesting that William Young thinks Christian community is unimportant or dispensable. But if he thinks it is important, he has failed to include it in his lengthy and detailed account of faithfully following Jesus. This jumped out at me as more than a trivial oversight; it's a glaring inconsistency, because otherwise the book's description of what Jesus wants with us is so biblical.

I wonder how many readers who really enjoyed *The Shack* felt as I did. Numerous students and others I encounter openly express belief that church involvement is not important to their faith. Many Christians and non-Christians alike view the church (a term I will use for Christian community) as a support group for people who need that kind of thing. At first I thought it must be because they suffered some sort of abuse or experienced a lot of hypocrisy in church. But more recently I've come to believe that's not what underlies Christians' noninvolvement in church.

Why do so many American people who consider themselves not only "spiritual" but also "Christian" avoid church? There are no doubt many reasons, but two obvious ones are that our culture encourages individualism, and church involvement is work. Many people have trouble finding a congregation where their "needs" are met or where they can "plug in" or where they "feel comfortable." Certainly, though, there are enough churches around that virtually everyone should be able to find one that fits to some degree. But even

searching for such a church can be hard work. And joining one means giving up some of our individualism; community automatically includes some measure of accountability to others.

Let's take a look at Scripture to see what it has to say about community.

COMMUNITY IN THE BIBLE

Hebrews 10:23-25 teaches that Christian community is essential to genuine Christian faithfulness:

> Let us hold fast the confession of our hope without wavering, for he who promised is faithful; and let us consider how to stir up one another to love and good works, not neglecting to meet together, as is the habit of some, but encouraging one another, and all the more as you see the Day drawing near.

Notice how the entire passage highlights reasons why Christian community is important to the life of faith. We are to "stir up one another to love and good works." We need to encourage one another, which doesn't happen much outside of Christian community. And it's critical for us to meet together.

This is just one small passage about the subject, but it's consistent with the rest of the Bible, which everywhere assumes that community is normative for faithfulness. In the Old Testament, prophets spoke harshly to their communities of faith, but they never rejected the people of God as irrelevant to faithfulness. They wanted to reform Jewish community, not abolish it.

In the New Testament Jesus never abandoned the synagogue or temple, nor did he encourage his followers to go on an individualistic spiritual journey. Jesus and his disciples were a community; they

even had a community "purse" for meeting their needs. The money came from certain rich women who supported Jesus and his disciples (Luke 8:3). And this community of Jesus followers extended far beyond the ranks of Jesus and the original twelve disciples.

The book of Acts is filled with reports of God working in and through churches. The Jesus followers in the first church in Jerusalem held all things in common—a kind of early Christian commune! They worshiped daily together and held each other accountable (Acts 2:43-47). The apostles didn't travel throughout the Roman Empire just to make converts; they also planted churches.

Most of Paul's letters were written to churches, and they depict close-knit Christian community among early believers. The same is true of other New Testament writings. The book of Revelation, for example, contains letters from God to seven churches. Anyone who carefully reads the New Testament cannot miss the fact that New Testament Christianity was communal.

From Genesis to Revelation and through the Reformation era, community is not treated as optional for God's people. But something very strange happened in the Western church with the eighteenth-century rise of Enlightenment thinking. People began to believe in a private and individualistic faith that could survive without the community of faith—the church.

During the 1970s *The Waltons* was a popular television show. The father, John Walton, was portrayed as a strong, sturdy, good father and man of faith. But when the rest of the family went to church, John regularly insisted that his "church" was the mountain where they lived. He worshiped God by himself among the trees and in the beauty of nature. His is a typically American spirituality. Even people who go to church think of their Christian faith in individualistic

terms and consider their best worship as something that happens just between God and themselves. The philosopher Alfred North Whitehead defined religion as something the individual does in his or her own solitariness. This fits well with how many people view their own religious life.

COMMUNITY IN *THE SHACK*

Now let's take a look at what *The Shack* says about Christian community. The foreword tells us quite a bit about Mack, including that as a thirteen-year-old he confided his father's abuse to a church leader at a youth revival. The man reported Mack's confession to his father, who then beat him within an inch of his life (p. 8). Later, we learn that Mack attended seminary in Australia and occasionally attends a church he and his friends call "the 55th Independent Assembly of Saint John the Baptist" (p. 10). We're told it's a "pew and pulpit Bible church" but not much else.

Mack is described in the foreword as skeptical and even somewhat cynical about organized religion. His "inside world" is described as "that place: where there is just you alone—and maybe God, if you believe in him" (p. 12). This uncannily sounds like Whitehead's definition of religion.

That's all *The Shack* tells us about Mack's religious life before his epiphany. The implication is that Mack is just like many of us: deeply wounded by a dysfunctional family and church, and turned in on ourselves, where we may occasionally commune with God—in our "inside world."

Does *The Shack* say anything about Christian community during and after Mack's epiphany—his revealing encounter with God? No. There is only silence on this subject. Mack's newfound relationship

with God is solitary; it's just Papa, Jesus, Sarayu and Mack. It changes Mack's life, however, and afterward—in the book's "After Words"—nothing is said about community except that his transformations "caused quite a ripple through his community of relationships" (p. 247). Though Mack's story changed his life and relationships, there's not a word about Christian community (unless Mack's friendship with the narrator is considered community) or church.

What should *The Shack* have said about church or Christian community? Insofar as its purpose is to teach us about trusting God, following Jesus and being transformed, it should include something about community. Especially in light of the negative statements about Mack's relationships with churches in the foreword. Shouldn't a real Jesus epiphany renew one's faith in God and his people? Shouldn't such an experience cause a person to seek out and connect with a gathered community of Jesus followers? I think so. The "After Words" at least should have included something about Mack's church life—even if only that he changed churches!

Real Christian renewal and transformation always includes the people of God because no Jesus follower can be totally isolated; that has never been God's plan.

So allow me to go out on a limb and suggest an alternate ending to *The Shack*. After his epiphany Mack is so changed that he is no longer satisfied trying to walk alone with God. Papa, Jesus and Sarayu revealed to him how important it is to accept the imperfections of fellow believers and love them unconditionally just as God loves him. So Mack asks his pastor for an opportunity to say something about his experience with the congregation. The pastor gives him the pulpit one Sunday morning and Mack tearfully tells them some of what God said and did for him. He confesses his previous disdain for

church and asks the congregation's forgiveness. Then he vows to walk among them as they follow Jesus together.

Sweet, isn't it? But I would add one more element that you might not like. During his tearful testimony Mack asks the congregation to consider what he heard God say to him and help him discern whether he heard correctly. After all, the world is full of evangelists who really believe God spoke to them, but they fall into all kinds of heresies and moral failures.

Let me offer some examples of the latter. I know a famous gospel singer and songwriter who really believes God spoke to him and led him into a fresh study of Scripture. As a result he no longer believes Jesus is God, contrary to the long history of orthodox Christian teaching.

When I was a college student I used to listen to a well-known radio preacher and author. He often recounted how God took him up into heaven, where he met and conversed with God face-to-face. God spoke to him in King James English ("Come thou up hither") and revealed things to him that are simply absurd. He developed the idea that God's Word has two dimensions—the Word for the past and the Word for the present. The Bible, of course is for the past, and his own (distorted) message is for the present.

Many people dismiss such evangelists as frauds. While I was teaching theology at Oral Roberts University many years ago, Rev. Roberts said publicly that God appeared to him and said Roberts would die unless he raised eight million dollars for his medical center—the City of Faith. The media scoffed and millions of people said that he was lying. Was he? I think he really believed something like that happened. But I doubt it was a real epiphany. People often think God is speaking to them when it's really their own imagina-

tion telling them something they want to hear.

One day while I was jogging God spoke to me. That's right. God spoke to me. Not audibly but just as powerfully and convincingly as if it were audible. To be frank, nothing like it had ever happened to me. I had a conversation with God. And in that epiphany God gave me a gift and told me to use it for a specific purpose.

Now, there was no heretical message in what God said to me, nor were his directions crazy or weird. But I knew enough Bible and theology to know I should submit this experience to my family of faith for discernment, which I did. I told it to my wife first, then to my pastor and also to my covenant group that meets weekly for prayer. All affirmed it was not just my imagination but most certainly from God. (One reason that was so apparent was the gift God gave me— an almost supernatural ability to do something that resulted in a blessing not for me but for a needy person.)

In my opinion the author of *The Shack* should have had Mack recount his experience to his family of faith for discernment. We Jesus followers need to realize our own frailty and tendency to hear from God what we want to hear. Thus we should offer our epiphanies to other spiritual people for their judgment.

The apostle Paul wrote to the Christians at Corinth about this very subject. In 1 Corinthians 14:29 he instructs the very charismatic Corinthians to prophesy and "let the others weigh what is said." He doesn't say to do this only if they think perhaps what they've prophesied might be incorrect. Paul assumes that whoever prophesies believes everything he or she says is from God. But he also knows that sometimes that's not the case!

The New Testament recounts when this principle is applied to Paul himself. Acts tells of Paul's missionary activity in Thessalonica, Berea

and Athens. Of the Bereans who heard Paul preach, it says they "were more noble than those in Thessalonica, for they received the word with all eagerness, examining the scriptures daily to see if these things were so" (Acts 17:11). The Bereans aren't criticized for examining Paul's preaching. In fact, it says they were more noble for doing so.

My point, however, is not so much about critically examining spiritual experiences and messages but about the importance of community for following Jesus faithfully. Becoming a faithful disciple of Jesus Christ means joining the band of faithful (and sometimes not-so-faithful) disciples. There are no Lone Ranger disciples of Jesus.

THE CHURCH BEYOND *THE SHACK*

Western Christians give up on the church too easily, and too many churches make that easy to do. Beginning with the latter point, too many churches make giving up on church altogether too attractive and easy. I have been a member of thirteen churches in my life. Partly because I've moved a lot. But also because I've found many churches seriously flawed. Some I judged as simply not real churches of Jesus Christ.

In spite of the many deeply flawed churches, too many Christians give up too quickly and drift into individualistic Christianity. But I can't judge them too harshly. I've experienced some deep disappointments with churches. I've also listened to friends who have given up their quests for functional Christian communities and settled for individual devotions or watching Christian television. Some of their stories are horrifying. Nevertheless, I don't think it's ever necessary to go it alone in one's spiritual life. It's always possible to find a functional Christian community of fellow strugglers on the journey of

following Jesus. Because of distance or other factors, perhaps connection with such a group will only happen occasionally, but giving up is never good or right.

So when is a person justified in giving up and leaving a church or family of faith? (By *church* I include all Christian groups that meet regularly for worship, even if only in a home.) There are probably too many good reasons to mention in this space. I left one church and sought another because I discerned that the gospel wasn't as important as looking respectable there. I didn't come to that conclusion alone; many others felt the same way. People who could not afford a nice car or nice clothes were not welcome there. One Sunday morning Native Americans were camped out in teepees on the church's lawn. They were protesting the church's affluence in the midst of a neighborhood of need. The church did nothing to accommodate them and did not dialogue with them. There was only harsh criticism of the protesters.

Another time my family and I left a church because the leaders engaged in harsh, punitive and even unethical treatment of pastoral staff members and their families. The church's pastor resigned under pressure from the board, and then the board pressured the congregation to fire the entire pastoral staff so a new pastor could come in with a clean slate. That church was behaving like a business and not like a church. A denominational representative told the church he could not in good conscience recommend any pastor to the church. We left because the church voted to fire the staff after being warned by spiritual leaders of the church that such an action would be unethical.

We didn't leave on a whim or because "our needs weren't being met." My family and I always found another church after such diffi-

cult departures. And, of course, our new families of faith were flawed as well. There's no perfection where sinners are involved, and we're all sinners.

It's time to leave a church and find a new Christian community when it is engaging in abusive, unethical or uncaring treatment of vulnerable people inside or outside its walls. It's time to leave when the church is teaching heresy or dabbling in unbiblical practices. It's time to leave when the church is simply spiritually dead beyond reasonable hope of revival. It's time to leave when the leadership is unaccountable.

What should we look for after we leave a faith community? First, we shouldn't wait too long. Too many of us fall into the trap of being comfortable with the Lone Ranger spiritual existence, and find it difficult or almost impossible to move into a new Christian community. Second, we should pray that God will lead us to the right place, asking the Holy Spirit to help us discern where to go. Never expect perfection. We should ask (1) Are the preaching and teaching biblical, and do they "comfort the afflicted and afflict the comfortable"? (2) Is the new church eager to grow with new blood and keep up with the times without being subverted by culture? (3) Are the people committed to each other in Christian love? (4) Do they serve the weak and vulnerable within and outside of the church walls?

There's no ultimate litmus test for finding a good church. We shouldn't expect any church to perfectly live up to our good standards. We should expect some disappointments, but not get disappointed too easily. But above all, we shouldn't wait too long to find a faith community and enter wholeheartedly into its worship and service.

11

Is Trusting God
All Sweetness and Light?

BY THE END OF *THE SHACK* MACK IS A changed man: "*The Great Sadness* is gone and he experiences most days with a profound sense of joy" (p. 247). After his encounter with Papa, Jesus and Sarayu, Mack becomes "the child he never was allowed to be; abiding in simple trust and wonder. He embraces even the darker shades of life as part of some incredibly rich and profound tapestry; crafted masterfully by invisible hands of love" (pp. 247-48). No doubt we're all happy for Mack. But is this true to life? Is it possible to lose a child in that way and find joy in life—even after an experience with God such as Mack had?

In preparation for writing this book I asked a lot of people who read *The Shack* what they thought of it. One woman's response stands out as especially poignant. She is a university teacher in her late fifties. She dismissed the book with a wave of the hand and a curt "Life isn't like that; the ending was too sweet and simple." (I'm paraphras-

ing what she said.) "I don't think a person who lost a child to kidnapping and murder could ever get over it and be happy in the way Mack did." I'm guessing many readers felt the same way. Especially if they had even a brush with such a terrible tragedy.

So how realistic is the story's ending? "And they all lived happily ever after" just doesn't sit well with most people today, unless it's the last sentence of a children's book. But *The Shack* gives us the ultimate happy ending. And what about the rest of the story? Could such a life-changing encounter happen? Should we expect it to happen to us? Is it normal? I don't think William Young would answer yes to any of these questions. Surely his aim was to share what he has come to understand about God and evil. So what can we take away from reading the book?

LIFTING THE GREAT SADNESS

First, Mack's burden is the Great Sadness, which is described as a dark cloud that presses down on him all the time. Clearly that's a description of clinical or major depression. Contrary to what many people think, most depressed people do go on functioning; they're just extremely unhappy. They have no joy. It's like the lights have gone out, but they can still grope around in the dark.

Most people can understand that losing a child, especially under the circumstances surrounding Missy's disappearance and murder, might very well send a parent into major depression. But there's a spiritual quality to Mack's depression; it's beyond the ordinary. It has a special quality in that it has settled into Mack's bones and taken over his life. He views the whole world through the lens of his loss. He's bitter toward God.

Second, Mack's deliverance from his Great Sadness requires a

miracle. Medicine won't do it. It might lift his spirits a little and help him cope better, but it won't bring joy back into his life. His joy is gone because, according to the story, he's bitter and doesn't trust God to be good. It almost would be better for him to stop believing in God than go on in this condition. But he doesn't stop believing; he just stops believing in God's goodness.

Third, Mack's miracle comes unexpectedly and just at the right time. Was it the answer to someone's prayers? We can only guess that maybe Mack's wife, Nann, was praying for such a miracle in his life. So God powerfully intervened in Mack's life to bring him out of his Great Sadness and restore his trust in God. Wouldn't it be nice if God always did that for people who have experienced crushing loss and lost their trust in him? But he doesn't. Why not? Well, *The Shack* is only a story.

If you believe in God, you have to believe in miracles. I can't count how many people I've met over the years who say they believe in God but clearly don't believe in miracles. They would think Mack's experience was a dream, and they would attribute his transformation to the natural healing of time or perhaps a chemical change in his brain. But why? If God exists and nature is his own creation; surely he can do with it whatever he wants. Could the Creator be bound by nature's laws? That doesn't make sense. If God exists, he can do miracles.

So there's no logical reason to think that Mack's epiphany couldn't happen or that he couldn't recover his joy miraculously. But normally it doesn't happen that way. And people who expect it to often become part of other people's Great Sadness.

My stepmother suffered a mental and emotional breakdown, and was absent from church for many months. She could barely drag herself out of bed to do anything. Her depression was so severe that she

was at times delusional. When she finally began to recover and returned to church, a superspiritual man met her in the foyer and said, "Oh, Sister . . . are you trusting Jesus more these days?" It made my stepmother want to go home and crawl back in bed.

But what if that superspiritual person had read *The Shack?* Would it have helped him to more sensitively approach other people's problems? Is spiritual depression always a result of not trusting God enough? Or is the Great Sadness rather a normal human reaction to loss and grief—even for Christians?

I don't doubt God's power to intervene in a person's life to lift their Great Sadness. I've known it to happen. It rarely happens over a weekend, however. And in every case I've known, some woundedness remains. I personally cannot blame anyone who has lost a child to tragedy for experiencing Great Sadness—including some amount of distrust in God. But it's one thing to harbor dark doubts and another to curse God. Dark doubts about God's goodness or nearness are surely natural in our condition of finitude and fallenness.

JOB AND THE GREAT SADNESS

Let's see what guidance the Bible has for this matter. One place to begin is the book of Job. There are many parallels between *The Shack* and Job, but there are also significant differences. For one thing, Job's sufferings were caused by Satan, with God's permission. (Some scholars debate whether Satan is "the Accuser" in the story of Job, but we'll leave that debate to one side.) Job's troubles were a test of his loyalty to God. In *The Shack*, though, God is not testing Mack. What Mack experienced is simply part of life in a fallen world. It happens. God didn't predestine, arrange or plan it. So Mack has less reason to distrust God than Job did! Of course, Job didn't know the reason for

his suffering, so psychologically the two felt the same—that God was somehow to blame.

Scholars have debated the point of the story of Job for centuries. Some say it is to teach that God is sovereign and whatever happens, no matter how bad it seems, it is for the glory of God. Others say the point is to teach that God is not the author of evil or innocent suffering, but he allows it and can bring good out of it if we trust him.

I think *The Shack* is an interpretation of Job. It's the author's perspective on the tragedy of innocent suffering. Where is God when innocent people suffer horribly? The book of Job's answer is ambiguous. First, it tells us that God removed the protective hedge around Job so that Satan could test him. Then, it tells us that, in spite of terrible losses and suffering, Job questioned God, but did not curse him. Finally, it tells us that God refused to answer Job's and his friends' probing questions. He simply asked them where they were when he—God—created everything. God left the question of why open. Clearly, however, a major point of Job is that we can trust God no matter what happens, and that trusting him will bring rewards.

The Shack's hero, Mack, is like Job. In the face of terrible calamity, the worst imaginable, he questions God's goodness. But he doesn't curse God; he simply doubts God's goodness and trustworthiness. Does God intervene in the same way? Not quite. Job's God brushes aside questions of God's motives and goodness, and tells Job and his friends that he is God and they must trust him. Mack's God enters into a lengthy explanation of why Mack should trust him. That explanation leaves some room for mystery. We're never told the precise reason God allows innocent suffering, only that he has his reasons, which have something to do with free will and this being a world of preparation for the next.

Job's final state, after God more than restores everything he lost, is blessedness. He seems to forget the children he lost before and simply moves on with the good things God provided as rewards for persevering in trust throughout his suffering. Something like that happens with Mack as well. So *The Shack*'s ending seems biblical.

STRUGGLING WITH PAIN, GRIEF AND SORROW

As Jesus died on the cross, he cried out to his Father, "My God, my God, why hast thou forsaken me?" (Mark 15:34). In the midst of his suffering the Son of God questioned God's presence. Did Jesus fail to trust his heavenly Father? That would be a stretch. Trust in God's goodness, however, didn't stop God's Son from crying out in protest to God.

The Psalms are full of laments to God. For example, in Psalm 143 David cries out to the Lord. In essence he pleads, "Where are you, God?" And in Lamentations, allegedly written by the prophet Jeremiah, the prophet says of God:

> He has filled me with bitterness,
> > he has sated me with wormword.
> He has made my teeth grind on gravel,
> > and made me cower in ashes;
> my soul is bereft of peace,
> > I have forgotten what happiness is;
> so I say "Gone is my glory,
> > and my expectation from the LORD." (Lamentations 3:15-18)

In his epistles the apostle Paul goes back and forth between expressions of despair and hope. "We were so utterly, unbearably crushed that we despaired of life itself. Why, we felt that we had received the sentence of death; but that was to make us rely not on

ourselves but on God who raises the dead" (2 Corinthians 1:8-9). In 2 Corinthians 12:7 Paul speaks of his "thorn in the flesh" that God refused to remove in spite of his earnest prayers. Yes, he came to realize its purpose, but I doubt he ever stopped grieving over it.

What does all this tell us? I think it confirms that it is normal and not un-Christian to wrestle with pain, grief and sorrow after a terrible loss. Life is not all sweetness and light, even when trust in God is restored. I don't discount the reality of Mack's sunny disposition after receiving such an epiphany. But I fear many of us will fall under guilt or shame if that doesn't happen to us. Does trusting in God's goodness free a person from the Great Sadness? Is it a sin to not fully trust in God's goodness? If *The Shack* implies an affirmative answer to these questions, it needs to be corrected at these points.

The Bible teems with people who had wonderful relationships with God and whom God used in powerful ways, but who nevertheless carried a burden of Great Sadness. King David is a good example. He sinned with Bathsheba, and as a result God took away their son. Should David have simply said, "I trust God's goodness, and now I'm happy"? I think that would be expecting too much of a mere mortal.

TRUSTING GOD WITH THE GREAT SADNESS

My point is that the Bible is realistic about our finitude and fallenness. It's also hopeful about God's power to change us. But even the most spiritual people in the Bible struggled with what we would now call depression. And church history reveals the same realistic picture of even the great giants of spirituality. Many of them struggled mightily with depression, including long periods of questioning God's goodness. The church father Augustine confessed to it. Martin Luther spoke often of his attacks of spiritual depression, which

never stopped recurring. The great eighteenth-century hymn writer William Cowper, author of "There Is a Fountain Filled with Blood" and numerous other hymns, spent years in insane asylums and sometimes questioned his salvation. C. S. Lewis was bedeviled by dark moods in which he questioned God's goodness, especially after his wife died. The great twentieth-century evangelical theologian E. J. Carnell, president of Fuller Theological Seminary, possibly died of an overdose of antidepressants.

The Bible and history simply do not bear out the idea that the Great Sadness simply goes away with trusting God. All these people trusted God. Sometimes more and sometimes less. But there's a real danger of reading *The Shack* and thinking depression and even doubt automatically go away when we trust in God. Christians can trust in God and yet feel dark despair; it's a normal human reaction to loss. Our brains are wired that way.

So how might *The Shack* have ended to correct this problem? I would suggest a more realistic condition for Mack. I imagine anyone who had a child kidnapped and murdered would remain forever broken. Yes, God and time can heal much pain, and a certain happiness might return. But we shouldn't judge such a person as they continue to ruminate on the lost child. It's normal for him or her to occasionally brood over the child and even cry out to God, "Why?"

When I was growing up in a "full Gospel" church, people used to ask each other, "Do you have the victory?" That meant "Are you living joyously and triumphantly above your circumstances, whatever they may be?" If not, that person usually was the subject of much prayer, and others were suspicious that he or she was less than fully spiritual. No doubt such attitudes still affect my view of suffering and its aftermath.

Therefore, I would amend the "After Words" to say that although Mack's Great Sadness lifted as a result of his unusual experience with God, he occasionally looks wistfully and with sadness into the sky thinking about Missy and wishing to be with her. And occasionally he wrestles with God's goodness even while remembering the assurances Papa, Jesus and Sarayu gave him. But he also operates out of a basic trust in God, believing he will make it up to those who suffer innocently and bring something good out of even the worst tragedy.

GOD IS GOOD

Events such as Missy's murder raise the question of God's goodness to fever pitch. There are many explanations that try to reconcile God's goodness with such horrors in history. None can be fully satisfying—if by satisfying we mean wiping away the emotional devastation and pain. But *The Shack*'s explanation is as good as they come. God allows whatever happens but neither foreordains it nor renders it certain. God allows whatever happens for reasons beyond our comprehension.

The most help I've found with this is from a wonderful but not particularly easy-to-read book titled *A Scandalous Providence: The Jesus Story of the Compassion of God* by E. Frank Tupper. Tupper argues that life is arbitrary, but God is not. In every tragic situation of innocent suffering God does all that he can do to prevent and alleviate it. Is God powerless? No. Tupper doesn't suggest that. Rather, God limits himself for the sake of human freedom. And God abides by rules about how often and when he can intervene. Another author, Gregory A. Boyd, suggests that prayer partly determines God's ability to intervene. In his book *Is God to Blame?* Boyd argues that God chooses to depend on our involvement in overcoming evil in

the world. Prayer is one of the factors that allows God to stop tragedies. Yes, God can sometimes intervene without prayer, but often he does not because he has chosen to limit himself.

This perspective has helped me tremendously. And I think something like it is being assumed in *The Shack*. Of course the novel does not get into the details, but Papa tells Mack that he can't *unilaterally* intervene to stop all innocent suffering (p. 190).

Such a point of view helps me believe in God's goodness in spite of all the horrible evils and instances of innocent suffering in the world. It seems to me that the message of *The Shack* is 90 percent right on. God is good and can be trusted, not to fix everything, but to care and do his best to work all things together for my good (Romans 8:28).

You see, for me, the most important issue of faith is believing that God is good. A God who is all-powerful but not good is of no interest to me. I would rather believe in a loving and good God who limits his own power. And I think that vision of a self-limiting and loving God is thoroughly biblical. Two major themes of the Bible are God's abhorrence of innocent suffering (he is good) and his waiting on us to pray so that he can act (he has limited himself).

THE PROPER RESPONSE TO TRUSTING GOD

Because God is good, I can trust him yet still experience profound grief and sorrow for the way the world is. I happen to think God experiences profound grief and sorrow over his fallen creation. Even for God all is not sweetness and light! If he grieves over a child's kidnapping and murder, and I can't imagine he doesn't, then surely no parent can be blamed for grieving even though he or she trusts God.

My own ending to *The Shack*, then, would portray the Great Sadness as gradually diminishing as time and Mack's epiphany work to

alleviate it. His profound sense of loss is still there. But in spite of that, he now feels something else. The spiritual heaviness that weighed him down and made him cynical and hard toward God is gradually lifting off his shoulders. He's beginning to feel intermittent joy in spite of continuing pain; he's getting back into the swing of life and relationships while still struggling on occasion with feelings of loss and sadness.

Would my ending satisfy most readers of *The Shack?* I don't know. Perhaps many readers would be turned off. Some people do like fairy tale endings. But are they real? I fear the author's ending implies that those who struggle with grief don't fully trust God. I'd rather read a realistic conclusion than one that seems out of this world.

12

How Should We Respond
to *The Shack?*

An endorsement on *The Shack's* cover compares it to the Christian classic *Pilgrim's Progress.* I'm not sure it rises to that literary height. However great and inspiring it may be, *The Shack* is just a story and not God's Word. My fear is that some enthusiastic readers may be tempted to elevate it to a status above what any novel deserves. While there have been amazingly popular and life-transforming books written since the Bible, all must be judged by Scripture and held to more lightly than it.

In 1896 Christian minister Charles M. Sheldon wrote *In His Steps,* which became the best-selling book after the Bible. Millions of people read it and were inspired by it; some of them placed it on a pedestal alongside the Bible, which was contrary to Sheldon's intentions. A century after the book's publication someone took its subtitle, *What Would Jesus Do?* and made it into a cliché: WWJD? It appeared on jewelry, bumper stickers and billboards. Interestingly, *The Shack*

takes a swipe at WWJD. Mack asks Jesus, "You mean . . . that I can't just ask, 'What Would Jesus Do?' " (p. 149). Their conversation was about relationships over rules. Jesus replies, "Good intentions, bad idea" and goes on to explain that his life was not meant to be an example to copy. That will surely come as a surprise to many readers! Instead, according to Jesus, "Being my follower is not trying to 'be like Jesus,' it means for your independence to be killed" (p. 149).

So here we have two great Christian novels, *In His Steps* and *The Shack*, in disagreement about the very meaning of being Jesus' follower. The point is that readers of both should remember that these novels are commentaries on God's Word and not God's Word itself. We have to decide which one to agree with (hopefully with the help of our community of faith, of course!). They can't both be right. I think both Charles Sheldon and William Young would agree with me that their novels, like the classic *Pilgrim's Progress*, are merely human visions of what Scripture means. They are inspiring, but not inspired.

This means that discerning readers of *The Shack* who are concerned about truth must be informed by Scripture. Too often Christians (to say nothing of others) substitute a comforting and inspiring message for the hard truths of the Bible. They read Christian biographies, novels and self-help books more than they read Scripture. That's a mistake. Of course, I'm not saying that Christians literally have to read the Bible more minutes per day, week and month than anything else. Instead, we should continuously read and absorb the meaning of the Bible. When we do, it becomes the lens through which everything else is interpreted.

Recent years have seen the publications of several best-selling Christian novels about angels and demons and the return of Jesus Christ. Many readers of these books are not sufficiently steeped in

Scripture to discern the good from the bad in them. They even get upset when a person points out something in their favorite Christian novel that is not in Scripture or is even unscriptural. Though the main message of *The Shack* surpasses most of those novels, even it should be subjected to critical thinking and not believed uncritically.

RESPONDING TO *THE SHACK*'S MESSAGE

So what might be a proper response to *The Shack?* First, don't start a ministry based on it. All too often when a Christian-themed book becomes a phenomenon, someone capitalizes on its popularity by creating a ministry. I can imagine someone buying some old cabins in the woods and taking people there to read *The Shack* in order to seek their own encounters with Papa, Jesus and Sarayu. Well, perhaps that's unlikely. But it's possible that someone may try to develop a church program based on it.

However, I think *The Shack* will make a great discussion starter for Christian (and perhaps other) small groups. In fact, as I write this, my wife and her church-based "Life Group" are about to gather at our home for their weekly meeting. They are reading and discussing *The Shack*. I'm sure that is happening in hundreds, if not thousands, of small groups. I suggest keeping a Bible nearby and subjecting everything in *The Shack* to it. As the Bible says, "test everything" (1 Thessalonians 5:21).

As for *The Shack*'s message, we should draw especially from its emphasis on God's goodness and trustworthiness in all our relationships. Comfort the afflicted by letting them know that God is not the source of their suffering and that he cares deeply about them even if he cannot relieve it (out of respect for free will). Also draw on *The Shack*'s message that relationships are more important than rules.

Authentic Christianity is not about *doing* so much as *being:* the Christian life is lived in transforming communion with God and not by following rules. Some Christians are more obsessed with the Ten Commandments than with Jesus. That's sad.

On the other hand, I've read many reviews of *The Shack*, and some of them are simply unfair to the book. They hurl accusations of heresy at it, but they clearly misunderstand it or read something into it that is not there. I urge readers to approach the book with an attitude of charity and generosity. Unfortunately, some Christian leaders think it's their duty to ferret out error in virtually everything. *The Shack* does contain some errors, but I haven't found anything blatantly heretical.

Heresy is not an easy term to define. But it is always a negative thing. Nobody claims to be preaching or promoting heresy. To properly understand what it is, we need to recognize there are two levels of heresy. First, there's heresy within the context of the Great Tradition of the church. Heresy in this sense, then, is denying a truth all branches of Christianity have believed and taught as essential to Christian faith throughout the centuries. There are only a few actual heresies within the Great Tradition: denials of the Trinity, denials of the deity or humanity of Jesus Christ, denials of salvation by grace alone, denials of the bodily resurrection of Jesus Christ and our own future resurrection. (There may be more.)

For example, most Christian denominations regard denial of the Trinity as heresy. A few groups flatly deny the doctrine of the Trinity as false and perhaps an invention of certain church fathers unduly influenced by the Roman emperor Constantine. But church history proves these groups wrong. The very earliest church fathers believed in the Trinity, and the Trinity is strongly implied in Scripture. In

fact, there's no way to make sense of Scripture without it!

Most controversial ideas proposed by Christians, though, do not rise to this level of heresy because they do not strike at the heart of the gospel. I don't find anything like that in *The Shack*.

It's important not to confuse imagery with doctrine. Just because some of the imagery used in *The Shack* is unconventional does not mean it is heretical. The author makes crystal clear that he does not think God the Father is literally a jovial African American woman. And he goes to great lengths to make clear that Father, Son and Spirit are one being and three persons. In spite of the imagery used in *The Shack*, the doctrine of the Trinity is clearly reflected in the God's words about himself to Mack. Some critics, I fear, are not distinguishing properly between imagery and doctrine when they criticize the book.

A second meaning of heresy is tied to the specific beliefs of a *slice* of the Christian tradition. If you are a Roman Catholic, for example, it is heresy to deny the infallibility of the pope. If you are a Protestant, it's probably heresy to affirm that belief! If you are a Protestant, you should confess that salvation is always "by grace through faith alone." But if you're a Roman Catholic, affirming the "faith alone" part may constitute heresy. So some heresies are contextual. When a person charges an author with heresy, he or she should explain what standard is being used as the criterion of truth and error. Some of the ideas in *The Shack* might be heretical within a certain denominational context. For example, some churches require ministers to swear allegiance to a certain statement of faith. It might include the doctrine that God unconditionally predestines some people to be saved and leaves others to condemnation. That implicitly denies free will—at least as it is defined and affirmed in *The Shack*.

Therefore some ideas in *The Shack* may constitute heresy or at least serious error within a certain denominational setting. So a pastor of a particular denomination may tell his or her congregation that the book is heretical because it strongly affirms free will and implicitly denies unconditional predestination. But there's even a problem here. Is William Young a member of that denomination? If not, he can't be accused of being a heretic! He's not bound by that denomination's statement of faith. So the responsible pastor might say to his congregation that this element of *The Shack* is heretical by their denominational standards without saying that Young is a heretic. That would be fair.

Even then, however, I think it is only fair to admit that "heresy" in this sense is relative to a particular denominational setting. Obviously, we need more words to describe doctrinal errors. When someone with authority says an idea is heresy, people may very well assume that means anti-Christian or denying the gospel of Jesus Christ. But it doesn't necessarily mean that.

FINDING HERESY IN *THE SHACK*

What are some of the so-called heresies allegedly found in *The Shack?* Some have accused it of promoting universal salvation. Others have charged it with being "man-centered" rather than God-centered. Still others have criticized it for denying a certain theory of how Christ's death on the cross works. And there are the claims that it teaches a false view of the Trinity. What's the truth about these accusations?

Let's start with the Trinity. In chapter three I discussed this matter. In my opinion there's nothing heretical about *The Shack*'s implicit doctrine of the Trinity so long as we realize the imagery is just

that—imagery. The doctrine behind the imagery stands up favorably to the Nicene Creed, the normative creed of most branches of Christianity, which says God is "one substance" and "three persons." *The Shack* doesn't use those words, and it shouldn't. It's a popularly written novel. But anyone who reads it carefully cannot seriously believe it conflicts with Scripture or the creed. If they do think so, they are importing a particular interpretation of the Trinity into both the Bible and the creed. That's all too common among heresy hunters. They take their own narrow interpretation of a doctrine and place it above the Bible and creed, and then they accuse anything that doesn't match their interpretation of being heresy. But that's wrong.

A careful assessment of *The Shack*'s doctrine of the Trinity is worthwhile and fair. It may fall short of being complete, and it may contain some distortions (see chapter three), but the book is not meant to be a systematic theology. For a novel, it's an adequate if not particularly illuminating account of the Trinity.

What about the charge that *The Shack* teaches universal salvation? First, let's see whether universalism—the idea that eventually everyone will be saved—is really heresy. To be sure it is not part of the historical Christian doctrinal consensus. The vast majority of church fathers and Reformers believed in and taught the reality of hell. However, some early Christian fathers, such as Origen and Gregory of Nyssa, believed in universal salvation. It is admittedly a heresy by most Christian denominational standards: Roman Catholic, Eastern Orthodox and Protestant. But does *The Shack* say that eventually all will be saved? It says Christ died for everyone. That's not universalism. The book makes clear that in order to benefit from Christ's atoning death a person must choose to have a relationship with God. Repentance and faith are implicit. I see no bla-

tant denial of hell in *The Shack* even though the reality of hell could be clearer in the book (see chapter six). A charge of heresy is never justified on the basis of silence. If that were the case, every sermon would be heretical because none explain *all* the essentials of authentic Christian faith!

Finally, what about the claim that *The Shack* denies the doctrine of the atonement? *Atonement* is a compound word. It was literally invented by a Renaissance Bible translator out of two words and a suffix: "at," "one" and "ment." In the cross we are made "at one" with God. It means "reconciliation." So, speaking literally, any teaching that says Christ has reconciled God to humanity and humanity to God is embracing the atonement. Some critics say that *The Shack* is heretical because it doesn't clearly articulate the "penal substitution theory" of the atonement. Of course, they don't think it's a theory, but it is not an essential part of the Great Tradition of Christianity. Some denominations, though, have chosen to make it normative for their churches. The penal substitution theory says that Jesus Christ suffered the punishment deserved by human beings. God's wrath, in other words, was poured out on Jesus Christ on the cross. This was taught by many of the Reformers. But it's not the only theory of the atonement held by Christians.

Anyone making the charge of heresy should be clear what they are saying. Are they claiming that a person must believe in the penal substitution theory of the atonement in order to be a Christian? That would rule out an awful lot of people throughout church history! Or are they saying that William Young wouldn't be able to minister in their denomination because he doesn't believe in that theory of the atonement? If so, that may be a helpful thing to say to a congregation or group of churches.

However, I'm not at all sure *The Shack* denies substitutionary atonement. Regarding Jesus, Papa says to Mack, "Through his death and resurrection, I am now fully reconciled to the world" (p. 192). My judgment is that *The Shack* neither clearly teaches nor denies substitutionary atonement. What it says is consistent with that doctrine, but it doesn't come right out and affirm it. It doesn't have to, does it? That's asking too much of a novel.

All things considered, I find many criticisms of *The Shack* problematic. I've offered my own criticisms in this book. But they have to do with elements of the story that might be misleading. It is one thing to suggest corrections and another to hurl accusations of heresy! I find no heresy in *The Shack*, and I worry about people who *think* they do.

Once again, let me be clear. *If* a person charging *The Shack* with heresy explains that the book doesn't quite live up to doctrinal standards of a particular denomination, fine. But most critics don't say that. They simply fling the label "heresy" at the book, which isn't fair-minded, charitable or even Christian.

LEARNING FROM *THE SHACK*

Overall, I believe *The Shack* is a force for good in today's world. Why? Because it faithfully portrays God's character through his fullest and most direct revelation—Jesus Christ. It testifies to the truth that God is absolutely good and trustworthy, and is not in any sense the author of evil or innocent suffering.

But *The Shack* will only be a force for good if people keep it in perspective. It's only a story written by a mere human; it isn't Scripture written by a prophet or apostle. In a word, it is inspiring but not inspired.

What might be a right response based on this analysis of the book? I suggest people speak up in defense of *The Shack* and its author when they encounter unfair or mean-spirited criticisms and especially charges of heresy against them. Without pretending it is flawless, fans of the book can defend its basic truthfulness and even its power to correctly change people's thinking about God.

More important, readers of *The Shack* should respond by appropriating the truths in it by trusting God in spite of negative circumstances and seeking to restore broken relationships with forgiveness and reconciliation. We should develop a relational picture of God's character as defined by Jesus Christ—loving, forgiving, compassionate and merciful.

Study Guide to
Finding God in the Shack

for Individuals or Groups

by Andrew T. Le Peau

The following questions are designed to help individuals and groups explore many of the provocative themes in *The Shack* by following Roger Olson's *Finding God in the Shack*. For groups, the questions for two chapters of *Finding God in the Shack* can be covered in a 45-minute discussion. So all twelve chapters can be covered in six sessions. You may also discuss Olson's book and *The Shack* in fewer than six sessions by selecting appropriate questions from the chapters you are discussing.

If you plan to discuss these books in a single session, a guide for that purpose is found after the questions for chapter twelve.

Page numbers in the questions, unless otherwise indicated, refer to *Finding God in the Shack* and are signified by FGS.

CHAPTER 1. WHY A BOOK ABOUT *THE SHACK*?

1. Why do you think so many people have been so affected by *The Shack*?

2. How were you affected?

3. Did you identify with Mack? If so, how? If not, why?

4. Does the story ring true for you—in the sense that the story basically fits human experience and what the Bible says? Explain.

CHAPTER 2. WHERE IS GOD IN SENSELESS, INNOCENT SUFFERING?

1. The problem of evil is one of the most difficult questions facing Christians. Two stories—one about the man who thought God took his son's life and the other who didn't think it was God's will his son died—are told

on page 20 (FGS). Which perspective makes more sense to you and why?

2. Where is God when we or loved ones suffer? Olson says that "according to *The Shack,* God is suffering along with us" (p. 22, FGS). How does *The Shack* illustrate that God is like this?

3. Another response *The Shack* offers to the problem of evil is that a loving God gave humans free will, and love does not force its way (p. 145, *The Shack*). How do you respond to this idea?

4. Does *The Shack* assure you of God's goodness? Explain.

CHAPTER 3. IS GOD REALLY A FAMILY OF THREE?

1. Many of us think of God as a sweet, grandfatherly figure or a harsh, punitive judge (p. 33, FGS). How do you respond to *The Shack*'s attempt to correct these folk images of God, especially by portraying God as Papa and Sarayu?

2. Olson believes *The Shack* is essentially in line with traditional Christian doctrine in its portrayal of the Trinity, remembering that it is a novel and not a book of systematic theology (p. 30, FGS). The Bible itself gives many images or pictures of God, such as loving shepherd, a woman of wisdom, a waiting father, a returning king. Which images of God are you most drawn to and find most helpful? Why?

3. One of the most important things about God being a Trinity is that God is love and love requires a relationship. If God were single and solitary, he could not be love. As Olson says, "Papa, Jesus and Sarayu eternally love one another" (p. 32, FGS). Does this make sense to you? Explain.

4. Olson takes some issue with the way *The Shack* describes how all three persons of the Trinity were involved at the cross (pp. 38-40, FGS). Only Jesus became human and only Jesus died; contrary to most Christian teaching *The Shack* hints that all three persons did. Nonetheless, how does *The Shack* help us understand that we can best know God through Jesus?

CHAPTER 4. IS GOD IN CHARGE BUT NOT IN CONTROL?

1. In chapter four Olson returns to the problem of evil in more detail. The question is: How can God be all good and all powerful and evil still exist? To answer this *The Shack* suggests that God limits himself by not controlling every detail of our lives out of respect for our free choices, and because love doesn't force its will on others (p. 46, FGS). Do you think God ever forces people against their will? Why or why not?

2. *The Shack* also suggests that God is redeeming and will redeem the world by bringing good out of evil, and that God makes it up to innocents who suffer (p. 49, FGS). Do these responses to evil make sense to you? Explain.

3. How does Jesus' attitude toward and response to evil help us understand God (p. 52, FGS)?

4. Olson concludes that because God appears to have limited himself, not always intervening in the world, "it is better to say, as does *The Shack,* that God is in charge but not in control" (p. 53, FGS). Do you agree? Why or why not?

CHAPTER 5. WHAT'S WRONG WITH THE WORLD AND US?

1. It's very popular in our culture to affirm our faith in the human spirit; that is, everyone has wonderful potential and is good at heart. *The Shack* portrays people and the world as being a mess. Do you think that's an accurate picture? Explain.

2. *The Shack* lays the world's problems clearly at the feet of human beings. We "have embraced evil" and drug all of creation down with us (pp. 59-60, FGS). How do we explain that some people seem very evil and others only modestly so?

3. One of the reasons Mack is so upset with God is that the world is such a mess, and God doesn't seem to have done enough to fix it. How have you been similarly angry or upset with God?

4. Olson sees *The Shack*'s portrayal of the human condition not as bad news but good news because it leads to the great news that our Creator hasn't given up on us. God sent his Son for us. In this way both the Bible and *The Shack* are realistic and hopeful (p. 66, FGS). Do you agree? Why or why not?

CHAPTER 6. DOES GOD FORGIVE EVERYONE UNCONDITIONALLY?

1. *The Shack* suggests that in and through Jesus' death on the cross, God has already forgiven us. Olson says instead "that God, in Christ, has laid the groundwork for forgiveness" for all of us. Forgiveness comes only when we accept what God offers (p. 75, FGS). Which perspective do you think is more accurate, and why?

2. Some think that to get people to do the right thing, we need to appeal to a stern God (usually the Father), but when we need forgiveness we go to Jesus (p. 70, FGS). William Young says such a dual version of God is wrong: God's fundamental disposition toward us is love, and Jesus perfectly reflects the Father's heart. Nonetheless, Jesus also had harsh words for religious leaders and quite challenging words for the rich. How can we reconcile these two aspects of God's character?

3. "God explains to Mack that instead of 'expectations' he has 'expectancy.' . . . Putting expectations on us only drives us into guilt and shame" (p. 73, FGS). How have you seen both expectations and expectancy at work in your life?

4. Olson says *The Shack* seems to leave "hell as at most a 'painful refuge' that God provides for those who stubbornly resist his love" (p. 77, FGS). What do you think of this notion?

CHAPTER 7. WHAT DOES GOD WANT WITH US?

1. What is *evil*? Olson agrees when *The Shack* says evil isn't something in itself, but the absence of good, just as dark is the absence of light. So

God couldn't have created evil since it only exists as the absence of something he did create. How does the illustration Olson offers about the cave in South Dakota help to explain something that is very real but was not created (pp. 81-82, FGS)?

2. "*The Shack* doesn't use this word *[sin]* very much, which may cause some people to think Young is soft on sin. However, a careful reading reveals he is almost obsessed with sin. . . . According to *The Shack*, sin is humanity's declaration of independence from God" (p. 83, FGS). How do you respond to this definition of *sin?*

3. *Salvation* in *The Shack* is restoring a relationship with God that was broken by our declaration of independence from God. God tells Mack that through Jesus' death and resurrection God makes salvation possible (p. 192, *The Shack*). What do you understand this to mean?

4. The last step in God's restoration project is the most difficult for Mack and for most of us. Not only must we trust God, we must also forgive others, including those who have hurt us the most. For Mack, of course, this is the Ladykiller. God tells Mack that forgiving is not forgetting, nor is it excusing. It doesn't mean abandoning justice, but that justice is left to God (pp. 89-90, FGS). How do you respond to being asked to forgive others in this way?

CHAPTER 8. WILL CHILD ABUSERS BE IN HEAVEN?

1. Chapter eight continues to explore the theme of forgiveness, especially for those who are guilty of heinous crimes like child abuse. Why is hatred toward such people often so strong, and why do we have a hard time contemplating forgiving them?

2. How do you respond to Olson's story about his relationship with his father (pp. 94-95, FGS)?

3. God tells Mack that he should forgive the Ladykiller for Mack's sake. How could doing this help Mack?

4. The basic question of chapter eight of *Finding God in the Shack* is

whether God forgives people regardless of how terrible their deeds are. How do you think *The Shack* answers that question?

CHAPTER 9. ISN'T JESUS A CHRISTIAN?

1. Mack is disillusioned with establishment Christianity. Why are there so many people like Mack, even among those who have been Christians for many years?

2. On page 182 of *The Shack*, Jesus tells Mack that people from many different backgrounds love him and follow him. What do you think William Young is trying to say by this?

3. On page 179 of *The Shack*, Jesus says he doesn't create institutions and isn't big on religion either. What does he mean? Explain why you do or don't agree.

4. Olson makes the case from Acts 10 and Matthew 25 that people can be followers of Jesus without being Christian, that is, without being part of a Christian church (pp. 112-15, FGS). Do you think he makes a convincing case? Why or why not?

CHAPTER 10. WHERE IS THE CHURCH IN EXPERIENCING GOD?

1. *The Shack* seems to imply that one can experience God fully apart from Christian community. Olson doesn't think it is necessary to be part of an organization or institution but that a follower of Jesus needs the fellowship of God's people, that there is no purely individualistic Christianity (p. 118, FGS). What do you think, and why?

2. What have been your positive and negative experiences with churches?

3. Olson makes a case for Christian community from the New Testament on pages 120-21 (FGS). How do you respond to what he says?

4. What do you think of the alternative ending Olson imagines for *The Shack* (pp. 123-26, FGS) and his reasons for it?

CHAPTER 11. IS TRUSTING GOD ALL SWEETNESS AND LIGHT?

1. How realistic is the ending of *The Shack*? Do you think someone could get over a tragedy like Mack's and be happy as quickly as he was?

2. Olson says Mack is a modern-day Job. Both struggle with why the innocent suffer, both question God's goodness but don't rebel against him, both have a deep, direct encounter with God and experience God's blessing (pp. 132-34, FGS). How similar or different do you think Mack and Job are?

3. Olson points out that Jesus, the psalmists, Jeremiah in the book of Lamentations and the apostle Paul struggled with pain, grief, sorrow and terrible loss (pp. 134-35, FGS). Do you agree such experiences are normal and not un-Christian? Explain.

4. Would you agree with Olson that the key issue of faith is believing that God is good (pp. 138-39, FGS)? Why or why not?

CHAPTER 12. HOW SHOULD WE RESPOND TO *THE SHACK*?

1. Some readers have appreciated *The Shack* so much that they take it to be as reliable as God's Word. Why is it important to remember it is about God's Word and not God's Word itself?

2. Others have analyzed it (to critique or praise it) as a book of doctrine. But *The Shack* is a novel and not a book of theology. How does this reminder help us?

3. Some readers and reviews have lodged strong criticisms of *The Shack*. What is the difference between labeling *The Shack* as heresy (against what Christians have believed throughout the centuries around the world) and saying it might not live up to the doctrinal standards of a particular denomination?

4. Olson says one of the reasons *The Shack* is so valuable is because "it faithfully portrays God's character through his fullest and most direct revelation—Jesus Christ" (p. 149, FGS). What do we learn about God through Jesus in *The Shack*?

A Single-Session Discussion Guide to
Finding God in the Shack

The following questions are designed to help individuals and groups explore many of the provocative themes in *The Shack* by following Roger Olson's *Finding God in the Shack* in a single 60- to 90-minute session.

Page numbers in the study questions below, unless otherwise indicated, all refer to *Finding God in the Shack* and are signified by FGS.

1. Why do you think so many people have been so affected by *The Shack*?

2. The existence of evil in the world is one of the main issues *The Shack* raises. Where is God when we or loved ones suffer? Olson says that "according to *The Shack*, God is suffering along with us" (p. 22, FGS). How does *The Shack* illustrate that God is like this?

3. Another response *The Shack* offers to the problem of evil is that a loving God gave human's free will, and love does not force its way (p. 145, *The Shack*). How do you respond to this idea?

4. It's very popular in our culture to affirm our faith in the human spirit; that is, everyone has wonderful potential and is good at heart. *The Shack* portrays people and the world as being a mess. Do you think that's an accurate picture? Explain.

5. *The Shack* also suggests that God is redeeming and will redeem the world by bringing good out of evil, and that God makes it up to innocents who suffer (p. 49, FGS). Do these responses to evil make sense to you? Explain.

6. One of the reasons Mack is so upset with God is that the world is such a mess, and God doesn't seem to have done enough to fix it. How have you been similarly angry or upset with God?

7. Olson concludes that because God appears to have limited himself, not always intervening in the world, that "it is better to say, as does *The Shack*, that God is in charge but not in control" (p. 53, FGS). Do you agree? Why or why not?

8. Many of us think of God as a sweet, grandfatherly figure or a harsh, punitive judge (p. 33, FGS). How do you respond to *The Shack*'s attempt to correct these folk images of God, especially by portraying God as Papa and Sarayu?

9. Some think that to get people to do the right thing, we need to appeal to a stern God (usually God the Father), but when we need forgiveness we go to Jesus (p. 70, FGS). William Young says such a dual version of God is wrong: God's fundamental disposition toward us is love, and Jesus perfectly reflects the Father's heart. Nonetheless, Jesus also had harsh words for religious leaders and quite challenging words for the rich. How can we reconcile these two aspects of God's character?

10. "God explains to Mack that instead of 'expectations' he has 'expectancy.' . . . Putting expectations on us only drives us into guilt and shame" (p. 73, FGS). How have you seen both expectations and expectancy at work in your life?

11. The last step in God's restoration project is the most difficult for Mack and for most of us. Not only must we trust God, we must also forgive others, including those who have hurt us the most. For Mack, of course, this is the Ladykiller. God tells Mack that forgiving is not forgetting, nor is it excusing. It doesn't mean abandoning justice, but that justice is left to God (pp. 88-90, FGS). How do you respond to being asked to forgive others in this way?

12. God tells Mack that he should forgive the Ladykiller for Mack's sake. How would doing this help Mack?

13. The basic question of chapter eight of *Finding God in the Shack* is whether God forgives people regardless of how terrible their deeds are. How do you think *The Shack* answers that question?

14. Mack is disillusioned with establishment Christianity. Why are there so many people like Mack, even among those who have been Christians for many years?

15. On page 179 of *The Shack*, Jesus says he doesn't create institutions and

isn't big on religion either. What does he mean? Explain why you do or don't agree.

16. *The Shack* seems to imply that one can experience God fully apart from Christian community. Olson doesn't think it is necessary to be part of an organization or institution but that a follower of Jesus needs the fellowship of God's people, that there is no purely individualistic Christianity (p. 118, FGS). What do you think, and why?

17. How realistic is the ending of *The Shack*? Do you think someone could get over a tragedy like Mack's and be happy as quickly as he was?

18. Olson points out that Jesus, the psalmists, Jeremiah in the book of Lamentations and the apostle Paul struggled with pain, grief, sorrow and terrible loss (pp. 134-35, FGS). Do you agree such experiences are normal and not un-Christian? Explain.

19. Some readers have appreciated *The Shack* so much that they take it to be as reliable as God's Word. Why is it important to remember it is *about* God's Word and not God's Word itself?

20. Olson says one of the reasons *The Shack* is so valuable is because "it faithfully portrays God's character through his fullest and most direct revelation—Jesus Christ" (p. 149, FGS). What do we learn about God through Jesus in *The Shack*?